PRO SECRETS

TO DRAMATIC DIGITAL PHOTOS

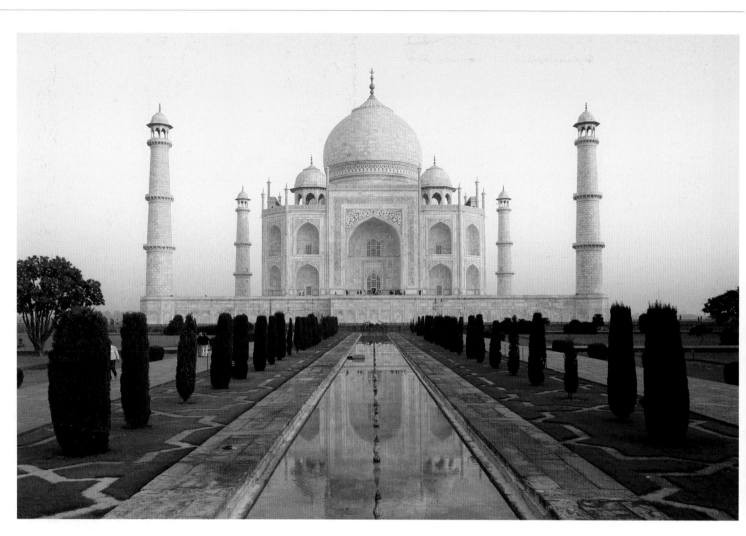

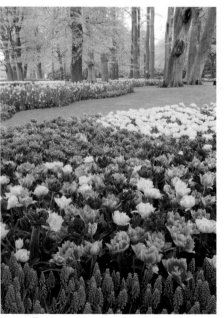

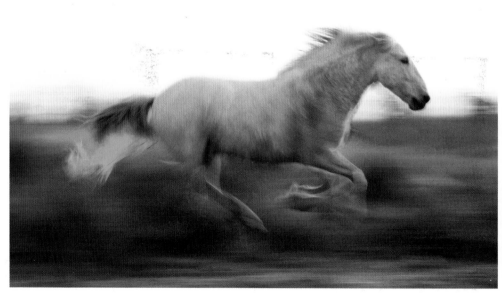

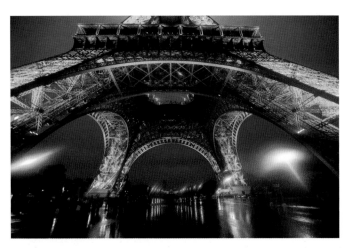
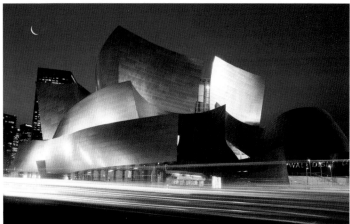

LARK
PHOTOGRAPHY
BOOKS

A Division of Sterling Publishing Co., Inc.
New York / London

PRO SECRETS
TO DRAMATIC DIGITAL PHOTOS

JIM ZUCKERMAN

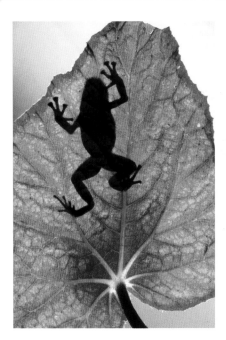
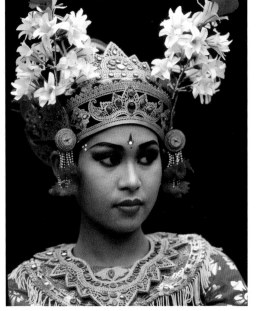

Editor: Rebecca Shipkosky
Book Design: Sandy Knight, Hoopskirt Studio
Cover Design: Thom Gaines, Electron Graphics

Library of Congress Cataloging-in-Publication Data

Zuckerman, Jim.
 Pro secrets to dramatic digital photos / Jim Zuckerman. – 1st ed.
 p. cm.
 ISBN 978-1-60059-638-4
 1. Composition (Photography) 2. Photography–Digital techniques. I. Title.
 TR179.Z835 2010
 775–dc22
 2010008098
10 9 8 7 6 5 4 3 2 1

First Edition

Published by Lark Books, A Division of
Sterling Publishing Co., Inc.
387 Park Avenue South, New York, N.Y. 10016

Text © 2011, Jim Zuckerman
Photography © 2011, Jim Zuckerman unless otherwise specified

Distributed in Canada by Sterling Publishing,
c/o Canadian Manda Group, 165 Dufferin Street
Toronto, Ontario, Canada M6K 3H6

Distributed in the United Kingdom by GMC Distribution Services,
Castle Place, 166 High Street, Lewes, East Sussex, England BN7 1XU

Distributed in Australia by Capricorn Link (Australia) Pty Ltd.,
P.O. Box 704, Windsor, NSW 2756 Australia

If you have questions or comments about this book, please contact:
Lark Books
67 Broadway
Asheville, NC 28801
(828) 253-0467

Manufactured in China

ISBN 13: 978-1-60059-638-4

For information about custom editions, special sales, premium and corporate purchases, please contact
Sterling Special Sales Department at 800-805-5489 or specialsales@sterlingpub.com.

For information about desk and examination copies available to college and university professors, requests must
be submitted to academic@larkbooks.com. Our complete policy can be found at www.larkbooks.com.

To learn more about digital photography, visit www.pixiq.com.

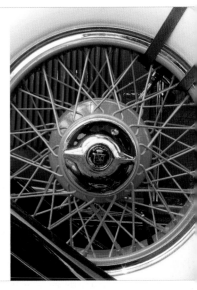
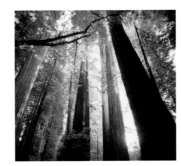
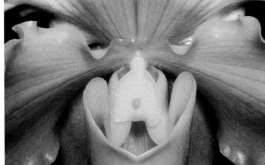

Chapter Six

Chapter Seven

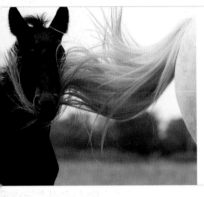

Chapter Eight

Chapter Nine

Chapter Ten

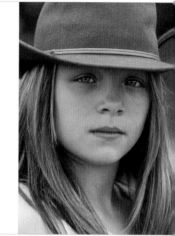

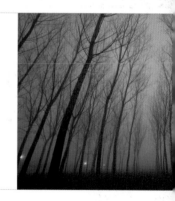

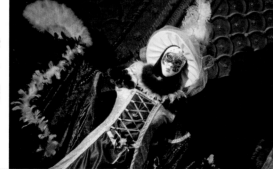

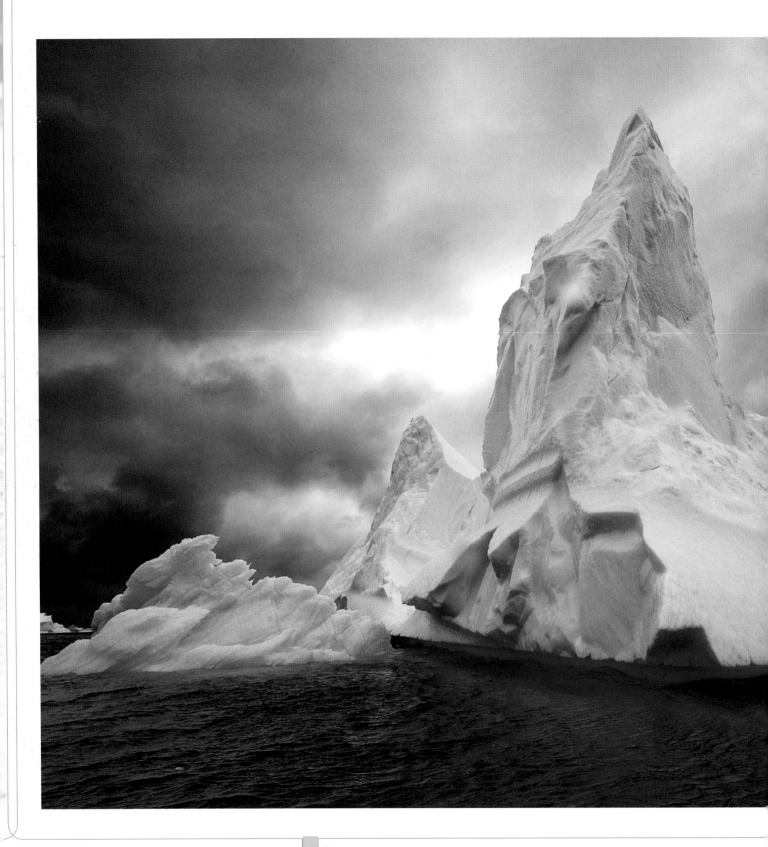

INTRODUCTION

have been teaching photography for a long time, and over the course of many decades, I've critiqued the work of literally thousands of students. In trying to help them improve their work, I have spent a lot of time thinking about specific steps they can take to produce images with artistry, impact, and beauty. The method I've used in coming up with guidelines for students is to compare my work to theirs, and then I try to dissect my pictures to find out why they are better—assuming that they are in fact better. Since I am asked so often to lecture on photography, to conduct photo tours and workshops, and to write books on all aspects of picture taking, I have to deduce that most people enjoy my work and want to learn how to take photos with similar qualities.

This book is a compilation of the 15 steps I feel are required to take great pictures. Each chapter is important in helping you to see images in your mind's eye and then use the right equipment to get the best results. I appreciate that art and beauty are in the eye of the beholder, and there may be times when you or an instructor may disagree with my approach. All I can tell you is that if you like my work and see elements in it that you want in your photos, then open your mind and internalize what I present in the following chapters. Follow the guidelines I give and take to heart my thoughts on the various aspects of making great pictures, and you will immediately see a quantum improvement in your photography.

To take great pictures, you don't have to have the most expensive equipment. Photography is very equipment oriented, and people get caught up in having to have the best gear. When you

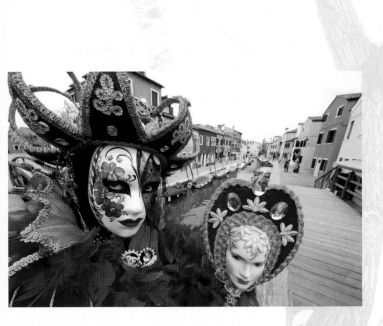

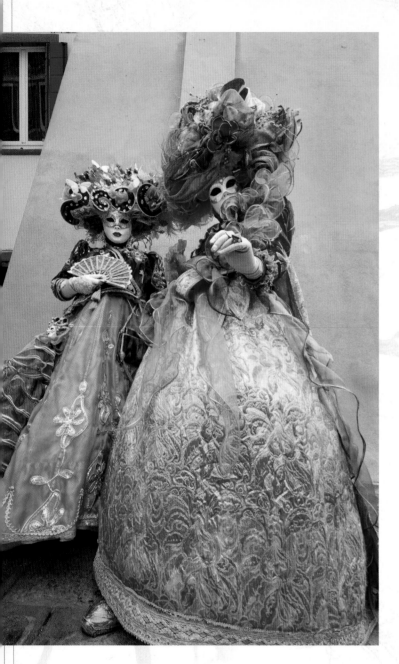

above
Never underestimate the ability of color to make a picture pop. Outrageous color combinations are like eye candy, and virtually all people respond in a positive way to images with brilliant color.

go out shooting with friends, camera club members, or on a photo tour, don't be intimidated by the equipment that other shooters have. In terms of excellent composition, exposure, lighting, and capturing wonderful moments, a camera that costs $500 can do just as well as one that costs $8000. Yes, there are more bells and whistles with the more expensive model, but the truth is that how successful the pictures will be is all about the artistry of the person shooting. And that's what this book will teach you.

Great images usually don't come easily. However, for those of us who have a passion for photography, it's a labor of love. Don't think for a moment that the pictures you see in this book were achieved with little or no work. Just the opposite is true. When I travel to faraway places, my neighbors and friends often say, "Have a nice vacation." They laugh when I tell them that I'll relax when I get home.

They think I'm joking. If you come on one of

my photo tours, you'll realize what goes into taking

great pictures. You'll be exhausted when you

get home, but you'll have taken the best pictures

of your life!

above
The secret to good pictures of pets is to get down to their level. Shoot eye-to-eye, as opposed to standing at an adult height and shooting downward. A low-angled perspective makes a more intimate and compelling portrait.

This first chapter is an unusual approach to helping you improve your photography, and I think it's the most important lesson in this book. I believe that if you take what I say to heart, you will be thrilled with the results.

SHOOT GREAT SUBJECTS

What Constitutes a Great Subject?

Consider this premise: If you could have captured it, a picture of Marilyn Monroe whispering something into President Kennedy's ear that showed them both laughing would have undoubtedly been awarded the Pulitzer Prize. It would be an extremely valuable photograph and you would have made a fortune on it. It would be considered one of the best and most recognized images of the twentieth century. All things being equal (lighting, composition, etc.), if you had a similar picture of my wife whispering in my ear, it would be a cute shot for our family album, but you could kiss the Pulitzer goodbye. Nobody would give it a second thought.

What's the difference between these two shots? The subjects. One shot would be seen as great, the other one would not be much more than a snapshot.

When you photograph great subjects, you'll likely get great pictures (assuming, of course, that the technical aspects of the picture are all correct). This seems so obvious that you may think it's not even worth mentioning. However, as I have critiqued the work of so many students over the decades, a big problem I see is that the subjects people choose to shoot are just not exciting.

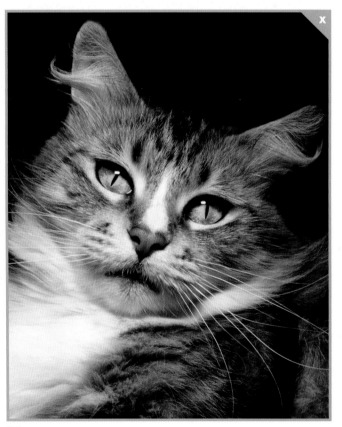

1.1

this spread
While this Maine coon cat is no lion in the savanna, I love to photograph my pets, and there are ways to really improve the quality of these around-the-house shots. One trick that goes a long way is to use a black background to eliminate distracting background elements. Another thing to keep in mind for any portrait (animal or human) is that the eyes always must be in focus. We can accept other parts of the face being soft due to shallow depth of field, but only if the eyes are sharp. You can see that I was careful to get the eyes in focus in both photos.

If you take nothing away from this book but one concept, I want you to remember this: Great subjects make great pictures.

What constitutes a great subject? This is very personal, of course. What speaks to one observer may not speak to others. In the following examples, I will support my premise with comparison shots of various subjects to drive home the point I'm making. Instead of comparing boring subjects with great ones, which is easy to do, I'll make these examples more realistic, more like the choices you often face. I'll compare good subjects with great ones. That way, you will be able to recognize that while a good subject makes a nice picture, that shouldn't be the goal. The goal, in my opinion, should be a great picture.

A case in point is the comparison images **1.1** (left), and **1.2** (right). The photo of the cat was done well. It's sharp, there's nothing in the background that takes our attention away from the cat, it has a beautiful face, and the lighting is attractive. In addition, I filled the frame, which gives this image much of its strength. I would call this a good picture. It doesn't knock your socks off, however. The tight closeup of the lion, on the other hand, is a picture that I would call great. It has the same qualities as the photo of the housecat in terms of lighting, composition, exposure, etc. The only difference is that housecats aren't awesome subjects. They are common, and they just don't have the same powerful presence that a male African lion has. Even people who love cats as pets have to admit that. Anyone who puts themselves in a position to get a shot of a lion in the wild will get pictures that are great. The bottom line, then, is that you have to expend the energy, the time, and often the money to seek out subjects that are great.

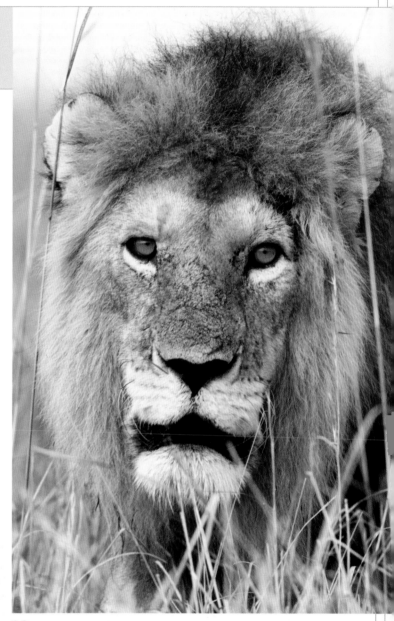

1.2

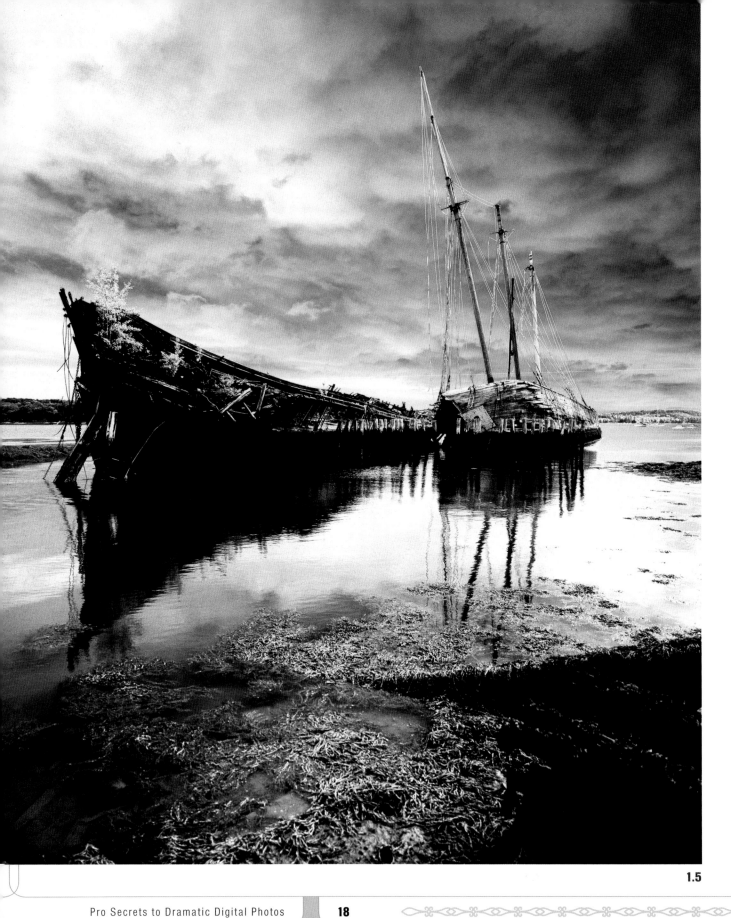

1.5

I can make the same argument for an endless variety of subjects. For example, the photo of the boat that served as my floating hotel in the Galapagos Islands (**1.3**, right) is a nice picture. Everything about it works. But, compared to the classic beauty of the tall ship I photographed off the coast of Norfolk, Virginia (**1.4**, below) it's a no-brainer as to which image has the most impact. The tall ship is obviously a great subject.

You may find it interesting that I also consider the two rotting schooners in photo **1.5** (left) to be great subjects. The moody lighting and the brooding sky above the old wooden ships help make this a strong image, but the subjects themselves are intriguing too. We can still see the elegant lines that once made these ships proud, and the

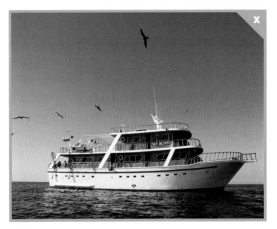

1.3

monochromatic tone I used added some artistry to the image. However, Photoshop effects aside, these are compelling subjects, and that's why this image holds our attention.

this spread
Generally speaking, finding great subjects takes time, energy, and often money. I made a special trip to the Maine coast to photograph the 1930s-era rotting schooners, at left, and I did the same thing to shoot the tall ships participating in a parade of ships in Norfolk, Virginia (right).

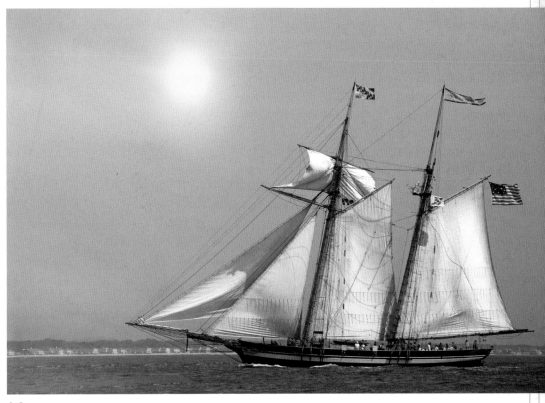

1.4

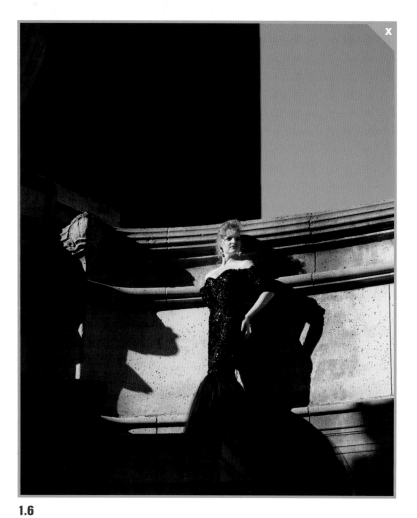

1.6

this spread
Two important factors make the scene in 1.7 a stronger subject than the one in 1.6. First, the classic Medieval architecture is much more dynamic than the architectural background at the Palace of Fine Arts in San Francisco. Second, the orange costume not only has a more elegant design, the color is striking, too. It focuses our attention exactly where we should be looking.

With fashion photography, several factors are used to define whether or not an image is good or great. A straightforward photograph of a woman in a business suit for the Sears catalog would hardly be called a great shot, but a stunning model in an evening gown in front of a European palace would be in a different league—and it would probably qualify as a great shot. I've always liked the photograph of a model at the Palace of Fine Arts in San Francisco (**1.6**, above). She's beautiful, the late afternoon lighting is dramatic, the dress is elegant, and her pose is professional. Is this a great image? I'd say no, it isn't. It's only good in my opinion. The picture I put together from Venice (this is a composite of a costumed model during the annual carnival in Venice and the second tier of the Doge's Palace in San Marco Square) is a lot more exciting because the clothing is outrageous and the architecture that frames the model is classic (**1.7**, right). According to my own sense of aesthetics, this is a great image simply because both the subject and the environment are captivating.

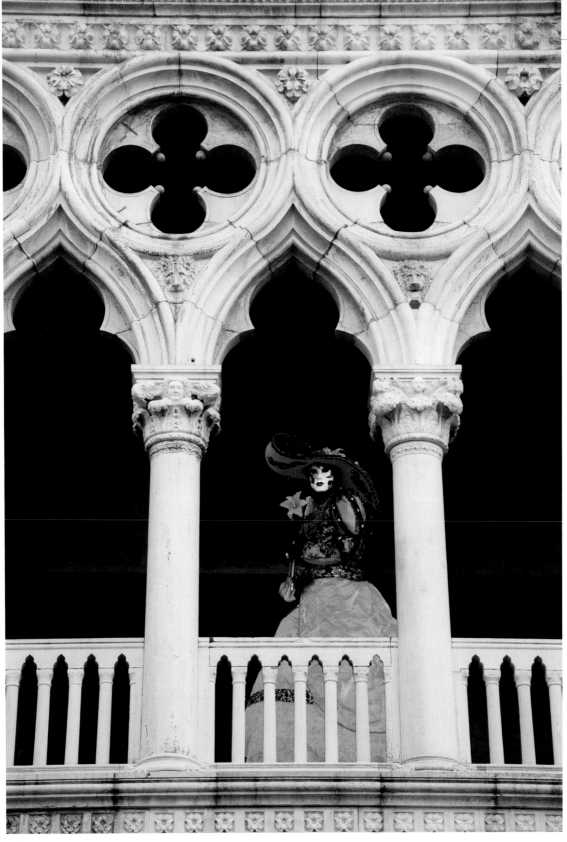

1.7

Chapter One

Good, or Great?

Great subjects make great pictures. The following image sets compare good subjects with great subjects in several different contexts. Keep in mind that even if you have a great subject, if you don't photograph it well, the picture won't be as strong as it could be.

good

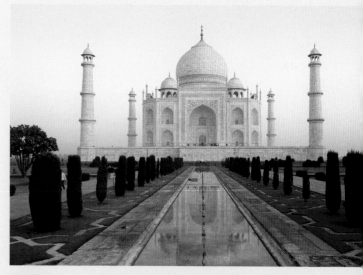

great

good

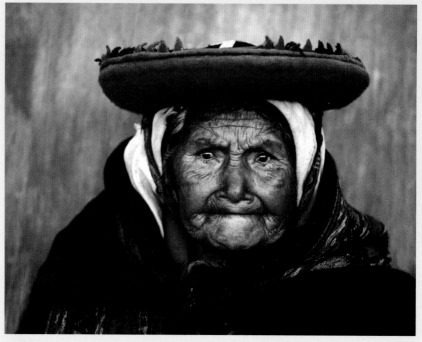

great

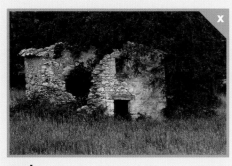

good

great

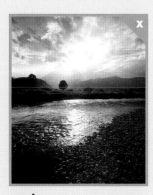

good

great

Finding Great Subjects

Great subjects aren't exclusively found in faraway places, of course. They can be as close as your backyard, or even your kitchen. A beautiful orchid on a kitchen counter illuminated by window light and set against a black velvet background, like photo **1.8** (below), certainly qualifies as a great subject. However, if you want to expand your picture taking to pursue many of the great subjects available to shoot, you will need to do research to find them. Since the Internet has virtually everything known to man on its billions of pages, that's the best place to start. For example, when I wanted to photograph tall ships, the first place I checked to find out where to go was the Internet. I simply typed into Google "tall ships," and found websites that listed the times and places where these classic sailing vessels

1.8

gathered. I chose the closest place to my home, and drove there for the several-day event. I rented a fishing boat along with some friends to defray the costs, and had a great time circling the ships to get the best angles during their Parade of Ships.

I also enjoy photographing classic cars. The best of the best are always seen at the Concourse d'Elegance exhibition that occurs in several places around the United States. In order to avoid having the busy car show background in all my photos, I not only do detail shots of the cars, such as the wheel detail on a 1913 Stutz (**1.9**, below), but I ask many of the owners if they would allow me to photograph their cars in more interesting locations on another day. I look for nature scenes, mansions

1.9

Chapter One

with beautiful driveways, the beach, and any other backdrop that I think would compliment the cars. Or, I use Photoshop sometimes to replace the backgrounds, eliminating all of the distracting elements typical of car shows. I did this in the shot of the beautiful 1939 Delange Aerosport (**1.10**, below).

When I travel, the Internet is essential in helping me find great subjects. A few years ago, I traveled to Malyasian Borneo, and never having been there, I didn't know very much about the area. I did a search for "Borneo photos" and discovered many interesting places that I never knew existed. One such unique location was Mulu National Park, which features a dramatic cave, and when I saw pictures of it, I knew I had to go there. The images I took in the national park's various caves were some of my favorite images from the trip. I took photo **1.11** in Deer Cave, looking out of the cavernous interior toward the opening.

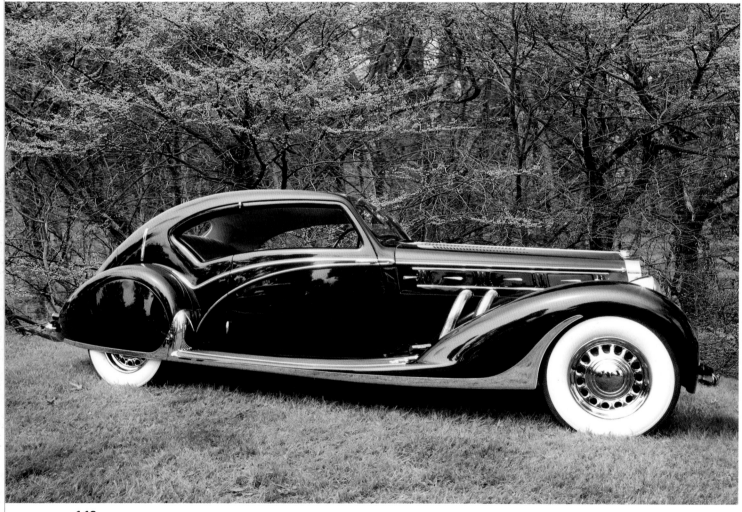

1.10

If you can't find what you are looking for initially, chances are there is someone that you can contact by email who can help you. There are bulletin boards and discussion groups where you can post a question, and usually people are very willing to share information. Before I went to Bali, Indonesia, for example, I wanted to track down the name and address of a butterfly farm that I was told was located somewhere on the island. I went to a website devoted to butterfly enthusiasts, found the bulletin board, and posted my question. Within 12 hours, I got an email from a man in Taiwan who gave me the information I requested. As a result, I got some exciting images of exotic butterflies, including one of the largest butterflies in the world, a birdwing (**1.12**, below).

I spend a significant amount of time in pursuit of great subjects. This is a fulfilling part of my life because it leads me down many fascinating paths, and it helps me get images that are exciting, intriguing, educational, and marketable.

this spread
The Internet has become my primary resource for finding great subjects. From classic cars to caves in Borneo to exotic butterflies, I can find out everything I need to know to help me capture exciting (and marketable) subjects.

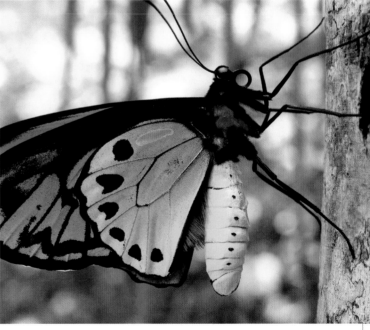

1.11

1.12

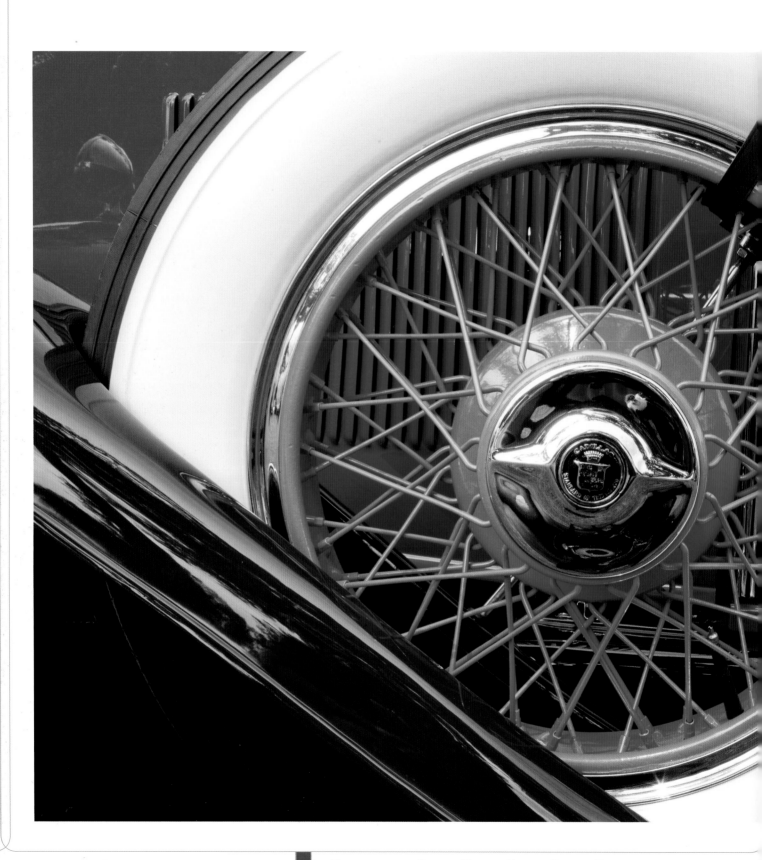

n the first chapter, I talked about choosing great

subjects because that has a direct bearing on

taking great pictures. If there is one defining

quality we can identify that characterizes a great

subject, it has to be this: Almost invariably, great

photos of great subjects feature graphic design that

is bold, beautiful, compelling, and/or artistic.

INFUSE GRAPHIC DESIGN

What is Graphic Design?

Graphic design is all about shapes and combinations of shapes. Looking for striking shapes and composing them the right way in your photographs can make a riveting graphic design of a scene that was only picturesque a moment ago. For example, some shapes are great, and the photographs are therefore successful, while other shapes are not, which may be because they are too busy and distracting, or because they are mundane and uninspiring. You can see an example of the latter by comparing the two horse pictures, **2.1** and **2.2**, below. Both of these are digital composites, but they make my point clearly. The shape of the rearing horse is powerful, graceful, and elegant.

The graphics of this image are beautiful because of the way the horse's legs are extended, the way its mane is flying, and the way it holds its head. On the other hand, the horse grazing against a sunset sky has a boring shape. It's common and doesn't elicit a second look, and even though the background is very pretty, the picture doesn't have any magic.

When I am photographically analyzing a scene or a subject, there are two primary things I think about: the lighting and the graphic design. Once the lighting is established as being satisfactory (such as sunrise, sunset, or diffused light), the rest of my thinking process is all about the design.

this page

Graphic design and lighting—these are the two prime ingredients that give photographs visual impact. This is true whether the pictures are composites, as they are here, or if they are unmanipulated. If you have beautiful lighting but the subject doesn't offer an eye-catching shape, like the horse with its head in the grass, the picture will be mediocre. Form and light will make or break your images.

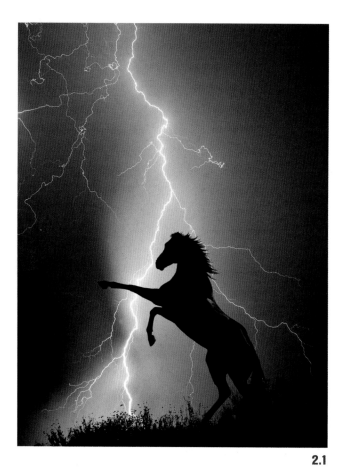

2.1

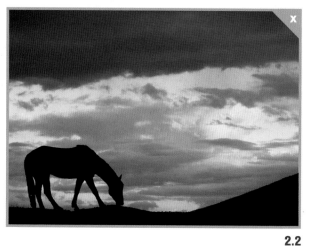

2.2

I look for simplicity, strong shapes, a background framed by something in the foreground, S curves, C curves, and lines that take the eye and lead it into the frame. You may be thinking, "He's talking about composition." Well, yes, but I'm talking about composing your images *artfully*—looking for just the right combination of shapes to make a powerful image. Each of the following sections details an exercise designed to help you take your images that extra step, from merely composed to graphically designed. Consider making each assignment the focus of your shooting for at least one entire outing in order to really familiarize yourself with each concept.

Simplicity of Design

Sometimes the most beautiful images are very simple. So, for this exercise, try photographing non-complex subjects with very simple lines. Make sure the background is uncluttered so all the attention can go on the subject, and make sure that nothing at the periphery of the composition interferes with the graphic subject. Look for elegance. For example, photo **2.3** (below, left) is simple and elegant, while photo **2.4** (below, right) is busy, complicated, and basically a mess—even though the sky in the background is beautiful. The great lighting and the rich colors are not enough to make this image work.

2.4

2.3

Chapter Two

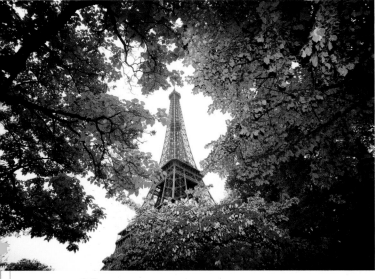

2.5

Frame the Background

Look for attractive foreground elements that can be used to frame a background scene you want to photograph. This can make a plain landscape photo really pop. Both areas of the image should be tack-sharp (there's nothing worse than an out-of-focus frame), which means that more than likely, you will need a tripod so you can use a small lens aperture for a deep depth of field. This is very important. Notice that in photos **2.5** (left) and **2.6** (below), the foregrounds that frame the backgrounds are both sharp and well defined. You can use many types of foreground elements as frames, from a natural arch in a rock face (like in **2.7**, right) to foliage, as in **2.5** and **2.6**. I suggest using lens apertures in the f/22 to f/32 range to make sure you have good sharpness from the immediate foreground frame to the background subject.

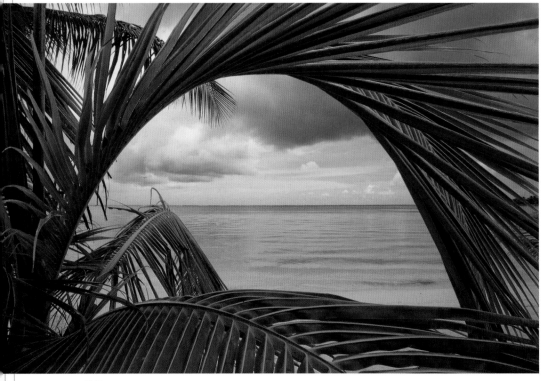

2.6

this spread

When you frame a distant scene with a foreground element, it's very important to use a small lens aperture for complete depth of field. This means that, to do it right, you need a tripod. Small lens apertures mean slow shutter speeds, which make for less-than-sharp pictures... unless you use a tripod.

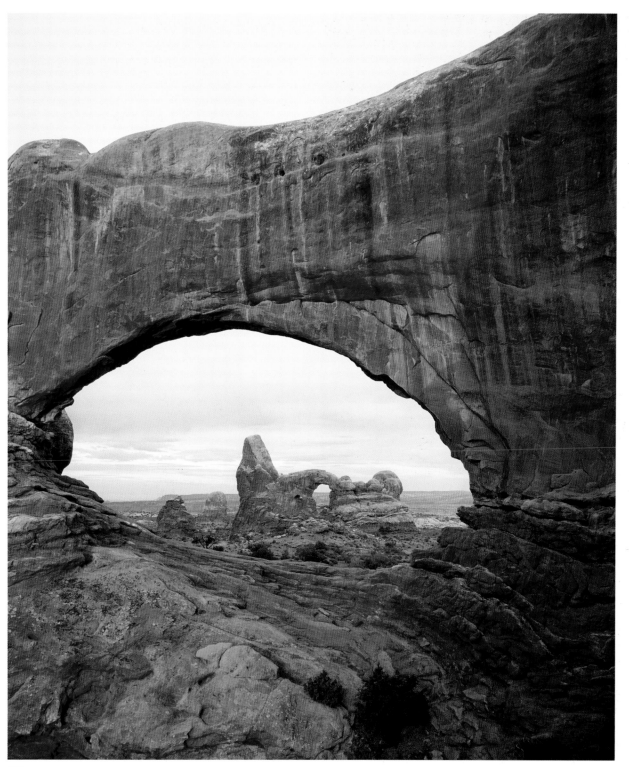

2.7

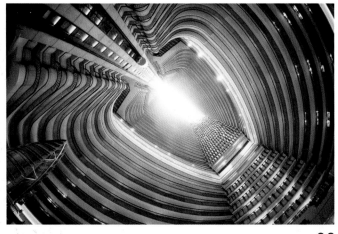

2.8

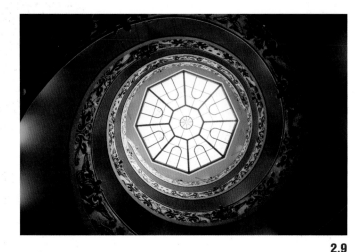

2.9

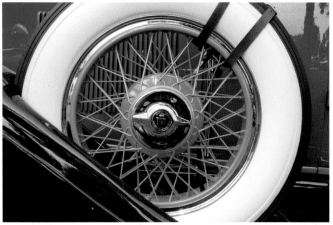

2.10

Seek Out Outrageous Design

Once in a while, we come across graphic design that is so stunning it takes our breath away. Spend the time and energy to find these subjects. They can be literally anywhere. As this book was being laid out, an ice storm hit the area of Tennessee where I live. I hadn't seen every branch, every twig, and every blade of grass covered in ice like that since I was a kid, and when the sun came out, it was amazing. Spectacular graphic design can often be found in nature—this is the first place I would start to look. If the overall landscape isn't great, start hunting for details like ice crystals, the insides of flowers, dewy spider webs, butterfly wings, and so on. Beyond that, architectural subjects are often impressive. Spiral staircases, stained glass windows, ornate lobbies, and gargoyles are some of the things I am always looking for.

Examples of what I consider spectacular designs are the hotel lobby of the Marriott Marquis in Atlanta, Georgia (**2.8**, this page, top); the staircase in the Vatican Museum (**2.9**, left); a detail of a classic car that I photographed in a Concourse d'Elegance car show (**2.10**, this page, bottom); a closeup in black and white—in this case, a high-contrast negative image—of a dragonfly wing (**2.11**, opposite, top); the underside of *The Bean* sculpture in downtown Chicago (**2.12**, opposite); the perfection of a dancer's form (**2.13**, top right); and the exquisite form of a sea dragon I photographed in a public aquarium (**2.14**, far right). These subjects, while they don't guarantee anything, certainly possess such design in and of themselves that they do lend themselves to compelling photographs.

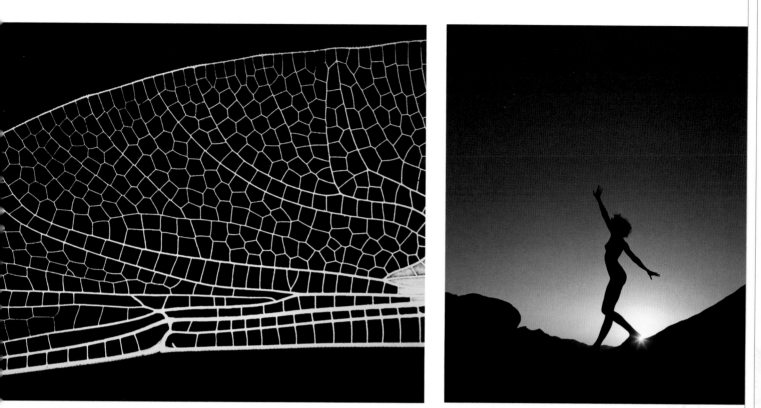

2.11

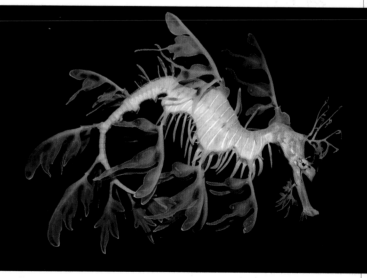

2.13

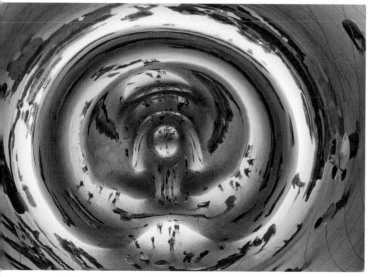

2.12

2.14

Look For Classic Curves

Curves are elegant. If you look at Classical Chinese art, you'll see that artists used curves in their motifs to great effect. Photo **2.15** (below) is a simple paper cut I bought in China, and it exemplifies what I'm talking about. You'll see a lot of S-curves in Chinese art, but curved lines can be found in different forms such as spirals, spheres, C-curves, and arches. Keep an eye out for these elements to impart some classic artistry to your photographs. You can even look to other fine art works such as paintings and sculptures to help you develop a sense for artistic curves in the real world. The rows of lavender fields in photo **2.16** (right), taken in Provence, France, are a prime example. To get this slightly elevated viewpoint, I stood on the top of my car so I could shoot down on the repetitive curves. Photo **2.17** (opposite top), shows an S-curve I captured from a commercial jet flying over the Midwest. The sun was low in the sky, and the glare of the reflection was intense. The artistry of the river course was a bonus. One of the most beautiful curves I've photographed is the spectacular spiral staircase in the Monastery of Melk in Austria (**2.18**, opposite). The curvature was embellished by the use of an ultra-wide 14mm lens. Even the spiral of the tail of a Jackson's chameleon (**2.19**, opposite, right) is captivating, and the unique curve of the reptile's arched back is also an attractive line that helps keep the viewer engaged.

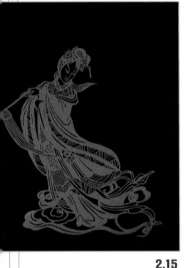

2.15

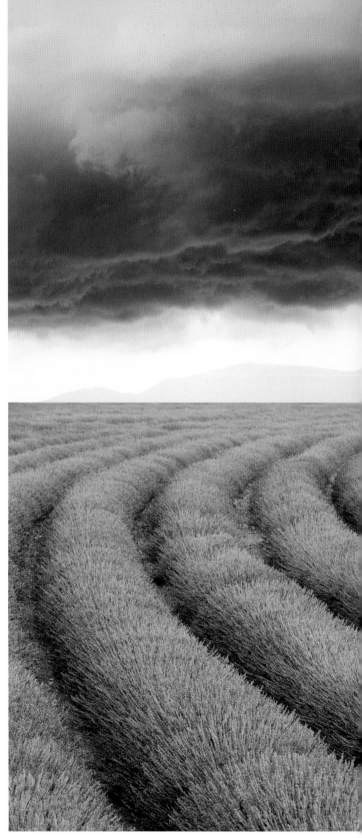

2.16

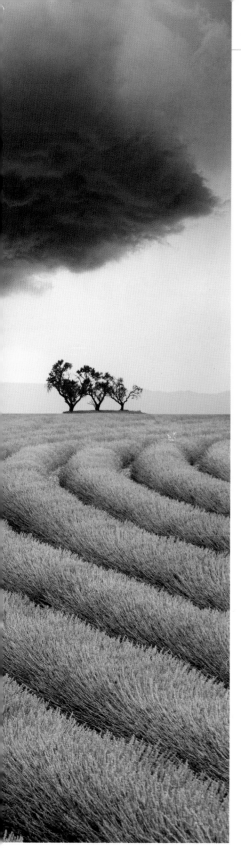

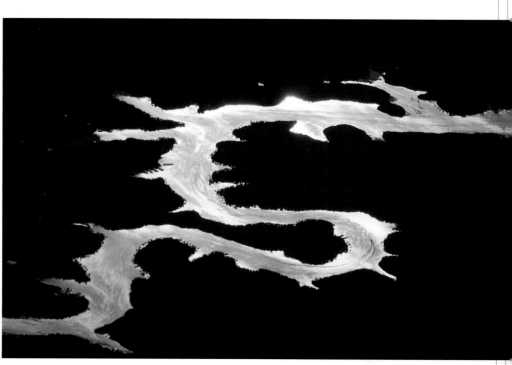

2.17

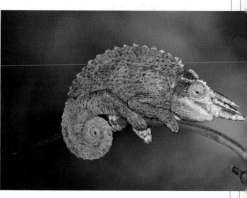

2.19

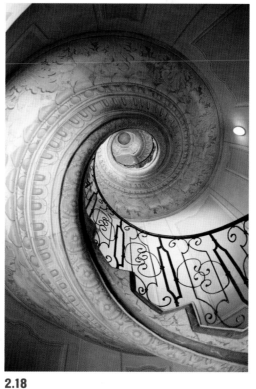

2.18

this spread
Once you recognize
the beauty of curves in
photographic compositions,
you will start noticing them
everywhere. They can really
add a sophistication and
elegance to your work.

Bold Diagonal Lines are Dynamic

Diagonal lines give a picture a lot of strength and artistry. If you don't see any diagonals in a composition, you can change that by angling the camera. This is what I did in photo **2.20** (right) in Venice. In the beautiful landscape of White Sands National Monument in New Mexico, photo **2.21** (below), multiple diagonal lines defined the gypsum sand dunes, and by making the sky black, I emphasized those lines. I digitally inserted the moon to give a sense of balance to the picture. In photo **2.22** (below right), the bold diagonal lines of Arthur Ravenal, Jr. Bridge in Charleston, South Carolina draws the viewer's eyes toward the moon.

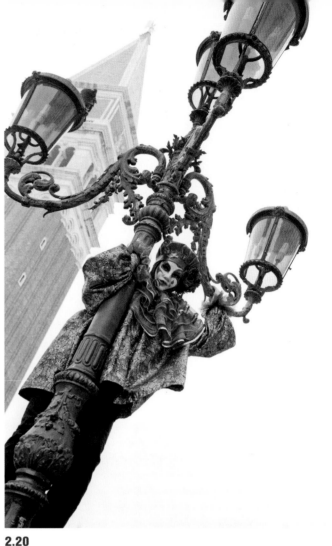

2.20

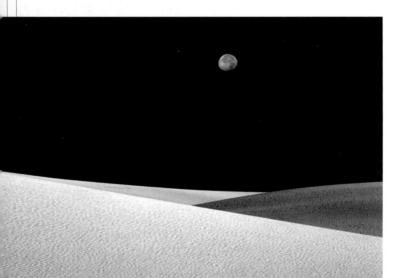

2.21

this spread

It is easy to recognize strong graphic elements that make photos successful once they are shown to you. Finding similar elements when you are out shooting is challenging, for sure. Be patient with yourself. When you are out shooting, concentrate on one or two ideas at a time—for example, diagonals and patterns. This will help you focus without feeling overwhelmed.

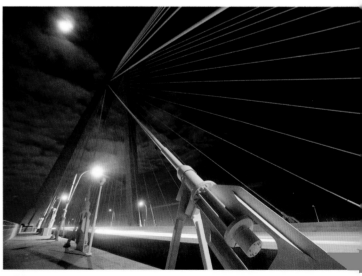

2.22

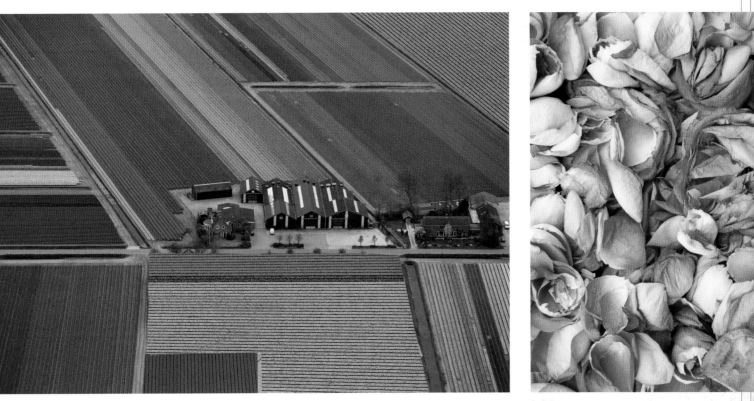

2.23

2.24

Pursue Patterns of Color and Design

Patterns that are striking to the eye make great photographs. Sometimes you find images like this unexpectedly, like the tulip fields in **2.23** (above), that I shot from an airplane. Other times, you can create your own pattern like I did with the dried rose petals in photo **2.24** (above, right) from a bouquet I had bought for my wife for Valentines Day. Notice how the picture is sharp from edge to edge. In a pattern photograph, that's important. Use a tripod whenever possible and make sure the back of the camera is parallel with the plane of the subject. Also, use a small lens aperture to ensure you have complete depth of field.

These exercises are designed to inspire you to focus on elements of graphic design that will help make your photographs more exciting and dramatic. Do them at your leisure, and invest time and thought into this. By seeking out the various types of graphic elements, you will see an immediate improvement in your work. Bear in mind, though, that graphic elements don't exist in a vacuum. You also must pay attention to the light, the background, the subject matter, and so on. For example, a powerful S-curve is great, but if the lighting is unattractive and the background is cluttered, the picture won't be successful.

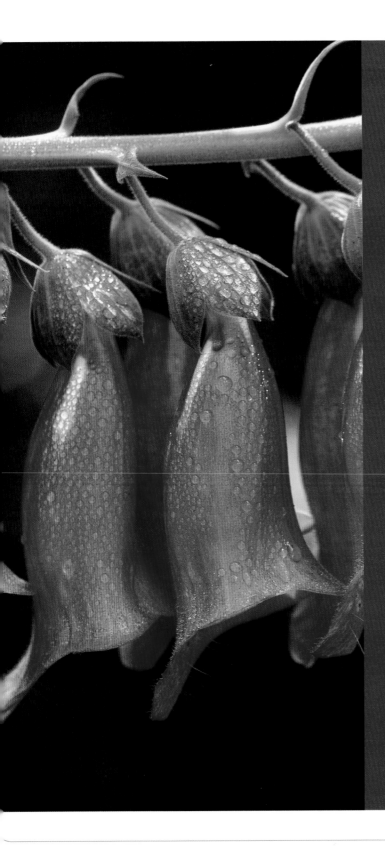

One of the best ways to draw attention to your photography is by shooting colorful subjects. This is an easy technique you can use to immediately impart more impact to your images.

The human eye is naturally attracted to saturated color, bold color combinations, and the juxtaposition of color with black and white, and if all other aspects of the photos are well executed (composition, exposure, background and foreground elements, and so on) they will be powerful images just because color has such a strong effect on us.

USE COLOR FOR IMPACT

What Kind of Impact?

Different colors and color combinations affect us in different ways emotionally and physically. Some are calming, like the ultra-subtle tones you get when shooting landscapes in fog, such as photo **3.1** (right), and some evoke a sense of excitement and mystery, like the outrageous blue frog from Suriname against the saturated purple flower in photo **3.2** (below). How you use color can make or break a photo, so lets examine some ways color can be incorporated into your pictures.

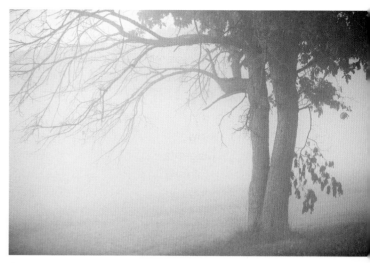

3.1

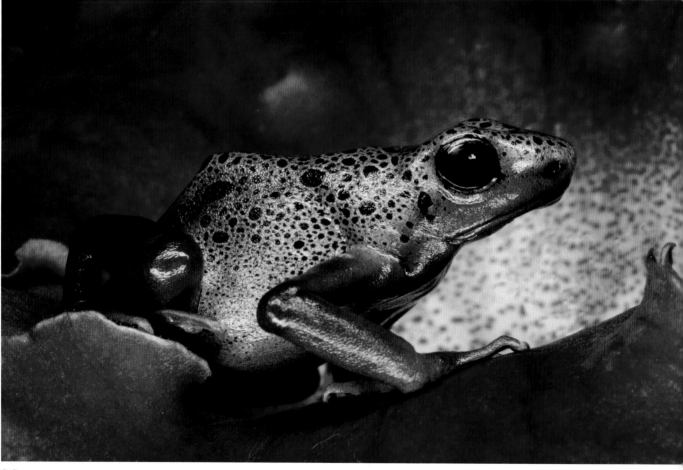

3.2

Complementary Colors

In color theory, there are six colors that are often referred to as *complementary pairs*. Contrary to the widely accepted color wheel, these pairs are, in fact:

- Red and Cyan
- Blue and Yellow
- Green and Magenta

These complementary colors are often arranged in a color wheel or as points on a six-pointed star, such as **figure A** (right). What this indicates is that the opposite colors on the wheel—the complementary pairs—always look good together in a photograph. An example in nature is the commonly seen juxtaposition of magenta flowers against a green foliage background, like the foxgloves in photo **3.3** (below). Similarly, the 1951 Mercury hotrod digitally composited with the landscape of spring greens in photo **3.4** (right) shows how striking these colors are together. Equally successful is the combination of blue and yellow seen in the uniquely painted police station in Istanbul, Turkey in photo **3.5** (bottom right). I shot this from a low angle to include the clear blue sky,

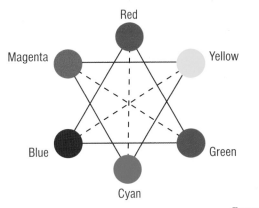

figure A

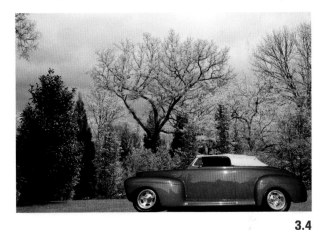

3.4

3.3

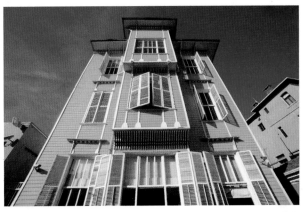

3.5

Chapter Three

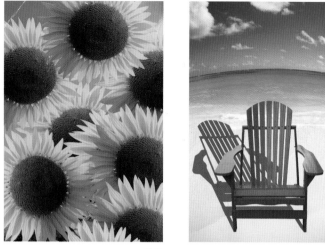

3.6 3.7

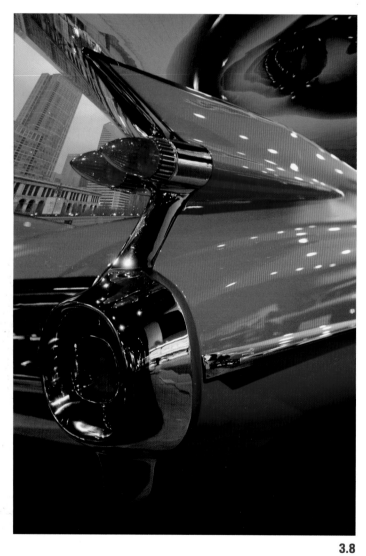

3.8

thus taking advantage of the juxtaposition of complementary colors. Another, more classic example of this use of blue and yellow is the mass of sunflowers against the sky in photo **3.6** (far left).

Cyan is not a common color, but when it's together with red, the result is always compelling, as in photo **3.7** (left). I shot this with a 15mm fisheye, hence the curvature of the horizon and the distorted perspective, but the color combination is what really makes it a striking image. In the digital composite of the 1959 Cadillac with *The Bean* in downtown Chicago (**3.8**, below, left). I tweaked the colors of the background and made them more cyan to complement the super-saturated red paint on the classic car. Whether they are shown with intense saturation or with muted subtlety, the complementary pairs of colors are always harmonious and attractive. Sometimes, though, disharmony is just as effective.

Shock Value

Placing subjects that are brilliantly saturated against non-complementary colors is a dramatic way to draw attention to your work. Shocking combinations like orange and green, cobalt blue and purple, and pink and red are like "eye candy." Color photography is never more exciting than when we shoot subjects that exhibit this quality of disharmony. The outrageous green carnival costume I photographed on Burano Island near Venice, Italy (**3.9**, top right) is a good example. The orange building served as a remarkable contrast to my model. The lilac-breasted roller pictured in photo **3.10** (right) is a famous bird among photographers on safari in East Africa simply because of its unusual colors. Blue, cyan, and purple predominate, and when these birds are in flight, the flashing colors of their wings are stunning.

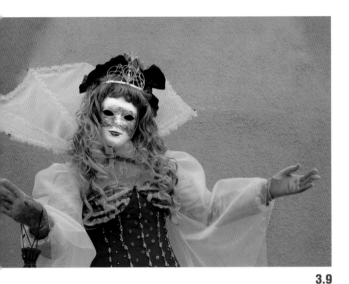

3.9

Overcast and Open Shade for Better Color Saturation

Notice that photo **3.9** (left) was taken in the shade. Even though the sun was out, I asked the model to move into a shaded location. Contrary to what most people think, bright sunlight does not make for bright colors in photographs; in fact, it sets up so much contrast that the dark shadows versus bright highlights are distracting to the subject. Soft light from an overcast sky or from the shaded side of a building actually makes bright colors seem more intense than if they had been photographed in the sun. The red tulips in **3.11** (below) were also photographed in the shade for the same reason. The striking color combination is successful partially because of the soft light I was using. This type of lighting is absolutely ideal for floral photography.

3.11

3.10

Desaturated Colors

At the opposite end of the spectrum, photographs with colors that are completely desaturated can also be quite attractive. The images seem somewhat ethereal and dreamlike. You can desaturate colors in Photoshop using Image > Adjustments > Hue/Saturation, or in Elements using Enhance > Adjust Color > Adjust Hue/Saturation, and then moving the Saturation slider to the left. I used this technique to desaturate the colors of the Taj Mahal in photo **3.12** (below) and in the landscape picture, (**3.13**, this page, right) taken in the Eastern Sierras. Note that even though autumn colors are usually represented as rich and saturated, in this case, the subtle earth tones are beautiful in their own right. This kind of image would make a lovely print on watercolor paper (like Somerset) that could go with almost any décor.

Using Photoshop, I increased the saturation of photo **3.14** (opposite, bottom left), taken in New Delhi, India, by about 15% in order to emphasize the rich, saturated colors, and it looks great; but also very attractive are the subtle colors in photo **3.15** (opposite, bottom right), where I lowered the saturation using the Saturation slider in Photoshop's Hue/Saturation dialog box (Image > Adjustments > Hue/Saturation) to create a very different impression.

Another approach to creating very subtle colors is to use Photoshop to apply various hues to a black-and-white image. By using the Brush Tool at a low opacity, you can attain a painterly look. For example, I converted **3.16** (opposite, top right) to black and white and then used the Brush Tool at

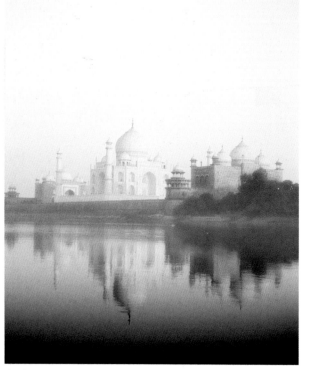

3.12

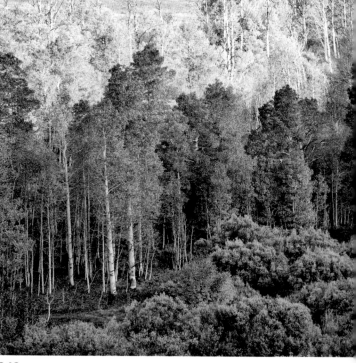

3.13

15% opacity to apply the colors to the scene. To create the black-and-white image, I selected Image > Adjustments > Black & White. Keep in mind that when you go from color to black and white, you always lose contrast. The diminished contrast has to be brought back to make the picture look good, and in the Black and White dialog box, there are a number of slider bars that allow you to control contrast in various parts of your image. Once you are satisfied with the black-and-white rendition, you can then use the Brush Tool to apply color anywhere you want it. This can only work if you leave the image as an RGB file. If you eliminated the color component (you do this in Photoshop here: Image > Mode > Grayscale), you can't introduce color unless you revert back to RGB using this command: Image > Mode > RGB.

3.16

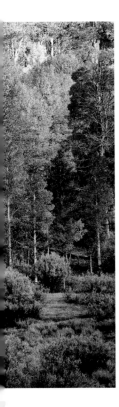

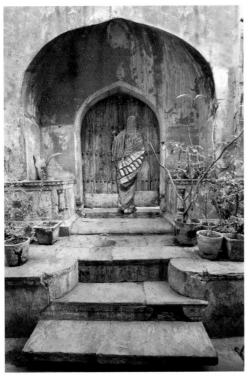

3.14

3.15

Toning

An elegant way of presenting a photograph is to tone it with a single monochromatic color. In the old days when we did this in the darkroom, photographers first made a black-and-white print and then we had a few choices as to which color tone we used to replace the silver halide on the paper. Sepia was a favorite tone and so

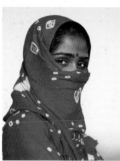

was selenium, which produced variations of yellow-brown or red-brown images, respectively. In the digital realm, we have an infinite number of colors to use and, of course, there are no chemicals to endure.

3.17

The first step is converting your color images to black and white by discarding the color information. In Photoshop, this is done with this pull-down menu command: Image > Mode > Grayscale. This is followed by Image > Mode > Duotone. It is here that any tone imaginable can be applied to your images. You can see in the comparison between photos **3.17** (left) and **3.18** (below, left), the bluish tone I added forces our attention away from the brilliant red that surrounds this young Gypsy woman in India and leaves us with only her beautiful eyes to focus on. I also used a bluish tone on the ruins of Angkor Wat, photo **3.19** (below). In conjunction with adding additional contrast, the monochromatic tone is quite effective in producing a striking interpretation of many kinds of subjects.

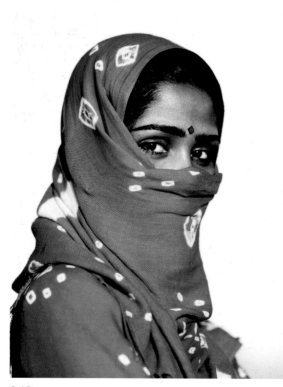

3.18

3.19

this spread
I love to use monochromatic color because it has such a classic look, and of the myriad tones now available in Photoshop, blue and sepia are my favorites.

The 1906 Cadillac in photo **3.20** (below) shows the typical sepia look. Sepia toning has always been very popular; it is so common in prints from the 19th century because the actual chemical process produced a more archival print than straight processing could. Today, because most prints remaining from that era are sepia-toned, we associate it with old photographs, which is why I used it for this picture of a horseless carriage. Sepia is great for many subjects, though, and in **3.21** (right), you can see that it was perfect for the graphic contours of landforms in the John Day Fossil Beds National Monument in Oregon.

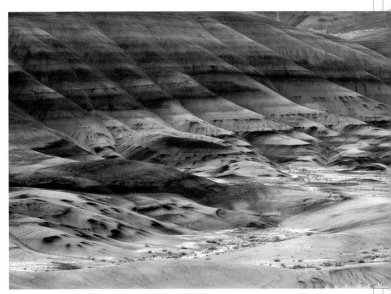

3.21

3.20

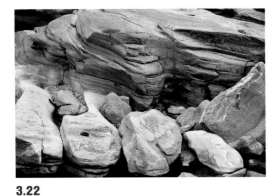

3.22

Hidden Colors

Thanks to our ability to manipulate digital images beyond what was possible in the past, there are colors within each image that I think of as "hidden." By that I mean they aren't immediately obvious unless you take the time to introduce additional saturation in Photoshop. Color that was originally grayish or light brown, for example, can change dramatically and become something very different.

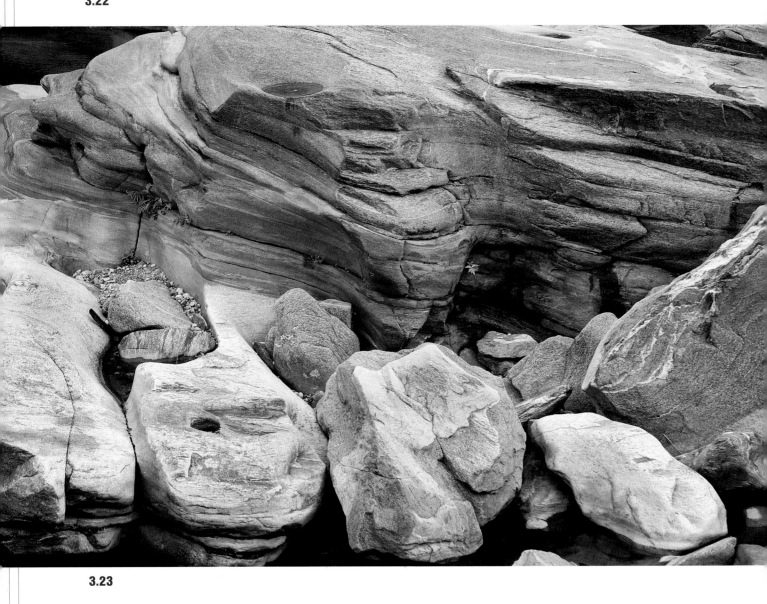

3.23

My favorite subjects for this kind of augmentation are rock surfaces, patterns in sand, and macro abstractions. Compare photos **3.22** (opposite, top) and **3.23** (opposite, bottom). I photographed these rocks at low tide on a beach near Monterrey, California with overcast light. The original image shows muted earth tones, but with a serious increase in saturation (Image > Adjustments >

Hue/Saturation), the intriguing design looks more like a painting than a photograph. Similarly, the pattern of peat washing over a beach in Ireland (**3.24**, this page, top) was captivating because of the natural contrast and graphic design, but when I went overboard with saturation in **3.25** (this page, middle), the image became virtually unrecognizable as a nature shot. It is now a bold abstraction of color and form.

Later that afternoon, after I returned from the beach, I watched trees outside the cottage where I was staying blow in a storm with 60-mile-an-hour winds. I was frustrated that the weather precluded going outside and shooting, so I experimented with slow shutter speeds as I shot through a window. It was about 20 minutes before dark so I was able to take long exposures in the muted light. Photo **3.26** (this page, bottom left) was taken handheld at $1/8$ second to capture the blurred motion of the leaves and branches. I liked the abstract result, but when I added a tremendous amount of saturation to reveal all of the hidden colors in the image (**3.27**, below), the result had nothing to do with what I saw in the storm. It is a complete departure from the subtle colors that I could see with my eyes.

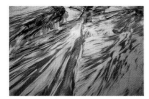

3.24

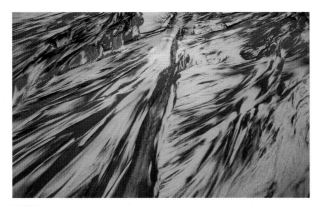

3.25

3.26

3.27

this page
Super saturated colors induced in Photoshop can transform an ordinary photograph into an image that looks more like a painting than a photo.

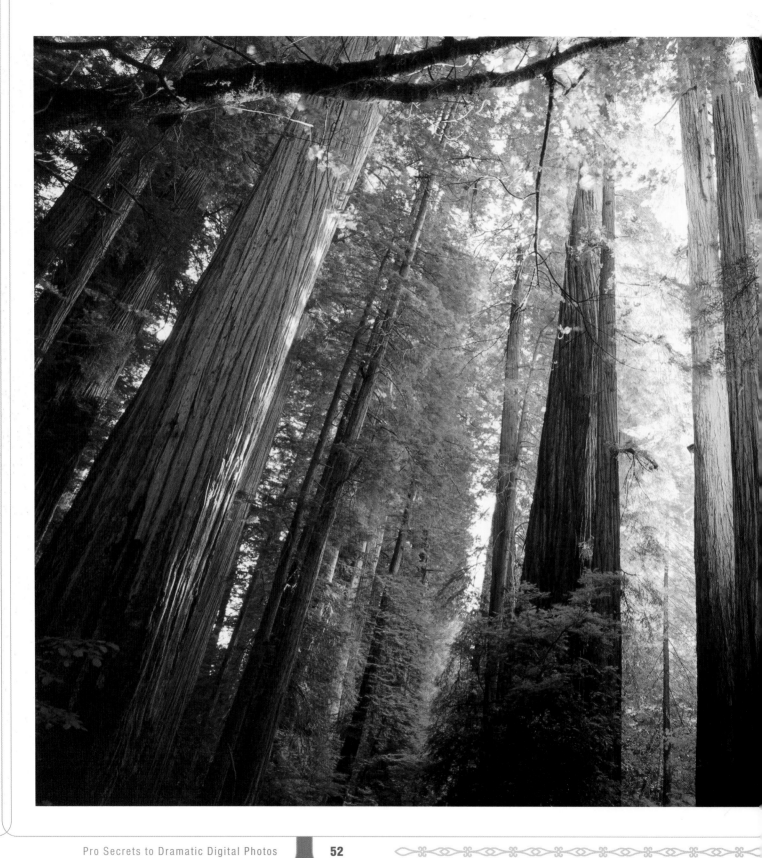

M any amateur photographers think it's not a good idea to shoot into the sun, but direct sunlight entering the lens can't hurt the camera at all, it won't injure your eyes if you do it correctly, and if you follow the advice set out in this chapter, it can make for some awesome photographs.

SHOOT INTO THE SUN

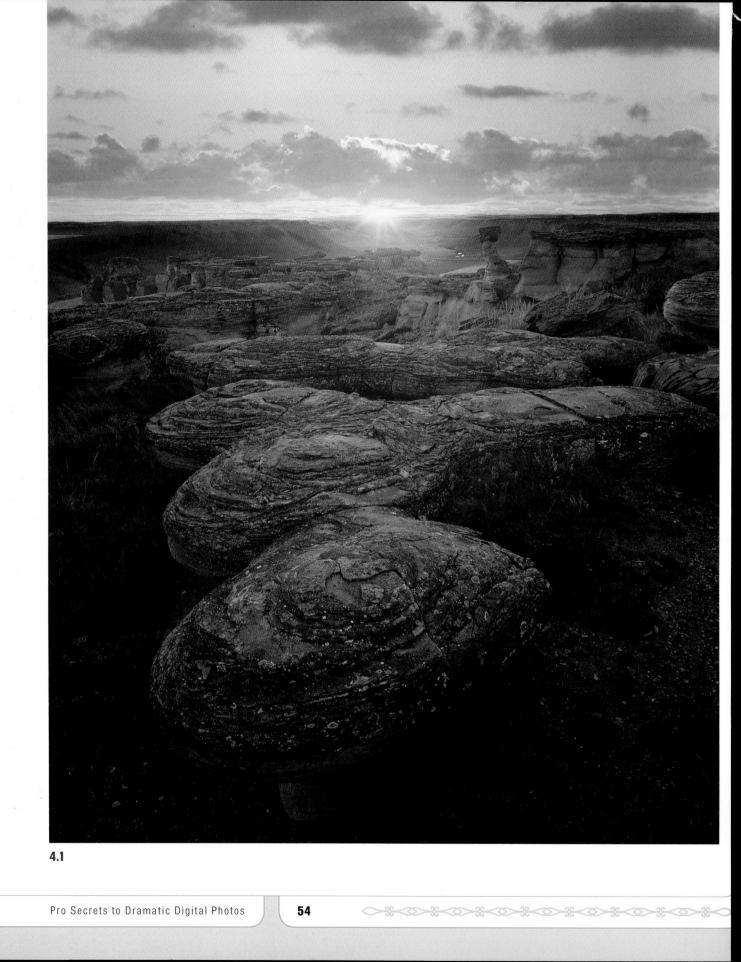

4.1

If you shoot the sun with a wide-angle lens, it will appear very small in the frame, like in photo **4.1** (opposite). This is significant for two reasons: First, this tiny speck of light can't hurt your eyes even if you stared at it all day; second, the diminutive size of the sun means that its influence on the meter reading is negligible. I'll explain how the sun can adversely affect the meter reading in a moment.

When you use a telephoto lens, the sun is large in the frame. The longer the lens is, the larger the sun will appear. For example, photo **4.2** (top right) was taken on Santorini Island in Greece with a focal length of 130mm. The leopard silhouette, **4.3** (middle right), was taken with a 500mm telephoto. You can see how the size of the sun increased when I used the big glass. Photo **4.4** (bottom right) shows an even larger sun because I used a 2x teleconverter with the 500mm lens, for a total of 1000mm.

Notice that all of these pictures were taken at sunset, and as a result, the light entering the camera was diminished significantly. Not only are sunrise and sunset the most beautiful times of day to shoot, but also, the sun is weak when it is close to the horizon, so it isn't painful to look at it in the viewfinder. I rarely include the sun in the shot during the middle of the day. For artistic purposes and to make it easy on my eyes, I usually shoot the sun within an hour or so after sunrise or an hour before sunset.

this page
Don't expect to capture detail when photographing the sun. It always looks blown out, and without texture or detail. The sun is the only subject in nature where this is acceptable.

4.2

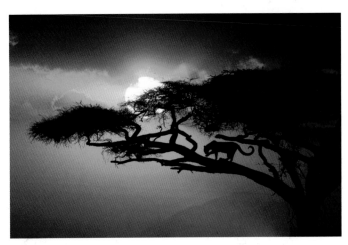

4.3

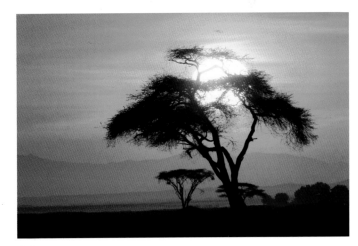

4.4

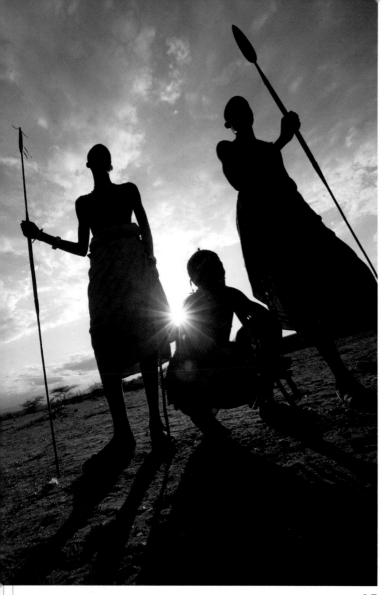

4.5

Star Effect

When you photograph point sources of light with small lens apertures (e.g., f/16, f/22), the lights typically look like stars with radiating beams of light. This is most pronounced with wide-angle lenses, but normal lenses and medium telephotos show a similar effect too. Any point source of light is affected, such as the headlights of cars, streetlights, bare bulbs, and of course the sun. Since wide-angle lenses make the sun appear very small in the frame, the definition of the star is quite sharp. When using a longer lens, sometimes I will partially hide it behind a branch, a ridgeline, or even a person, so it appears smaller, and that way, I am assured of the star effect.

For example, in photo **4.5** (left), I positioned myself so the sun was partially obscured by the shoulder of one of the Samburu tribesmen I photographed in Kenya. I think the star effect adds a dynamic quality to the picture. I used a 16mm wide-angle lens to shoot this, and even though the sun would have formed a star without being partially obscured, I knew that if it looked smaller, the star would appear more defined, making a more compelling addition to the composition.

this page
On most cameras at their default settings, the closer the sun is positioned near the center of the composition, the more influence it has on the light reading. Get to know your camera's metering system, and you'll gain some control over how it reads light.

4.6

Similarly, in photo **4.6** (below, left), I shot from a vantage point such that the sun was peeking from behind the branch of this hoarfrost-covered tree in Lone Pine, California. This was taken with a medium telephoto (130mm) and to make sure I got the star effect, I made the sun appear as small as possible. To ensure I get a nicely shaped star, I typically use a lens aperture of f/16 or smaller.

Exposure

When you include the sun in the composition, exposure can be challenging. This is because the sun is so brilliant that light meters don't know how to handle it. What often happens is that the pictures turn out too dark.

To understand why the built-in light meter in your camera can be deceived into producing under-exposed pictures, you have to know how light meters work. All meters are programmed to produce correctly exposed photographs when they detect middle-toned, or "middle-gray," subjects. (The term "middle gray" refers to tone, not color, so that means middle red, middle green, etc.). For example, a person wearing a red shirt and blue jeans standing in front of green foliage is an almost entirely middle-toned scene, and it is exactly what the meter is designed to expose for. Photos **4.7** and **4.8** (below) are examples of the type of middle-toned scenes that meters are programmed to understand. In both shots, you can see some shadow areas and highlights, but the overall subjects are middle-toned.

The problems begin when you have too much contrast. The brilliant sun juxtaposed against clouds or landforms is an example of contrast that is so extreme that the outcome may not be what you want. The meter only understands middle gray, and therefore the resulting exposure is an attempt at rendering the sun and the bright sky around it middle-toned, resulting in underexposure. Or, conversely, the camera may attempt to render dark areas of the image middle gray, thereby overexposing the image. Either way, it's problematic.

right
All meters are programmed to interpret middle gray tones (like in the two images at right) correctly. It's when images are predominately very light or very dark, or when there is significant contrast, that they can fail to give you a proper exposure.

4.7

4.8

What is the solution? There are two approaches you can use to arrive at the correct exposure. First, you can take the meter reading in another area of the frame, away from the sun, so that the meter isn't detecting any direct sunlight. Point the camera toward a middle-toned part of the sky, such as a solid blue area or a gray cloud, and take the reading using the spot-metering mode. This will force the meter to see only a narrow angle of the entire scene (about 3 to 5 % of it), allowing you to control, to a certain degree, the area that is used for the reading. Depending on the camera and the current settings, you may need to push a button in order to lock exposure so you can recompose the frame once you've gotten a reading. You will increase the accuracy of this technique if you use a telephoto lens to take the reading because it will further narrow the angle that the light meter uses to read the light. The red circles in photo **4.9** (below)

mark two areas that are middle gray; if you use areas like these for metering, the exposure will be correct. When I took this shot, I used the area that the upper left circle indicates and got an accurate exposure.

An alternative solution is to simply take a shot, study the LCD monitor on the back of the camera, and if the picture is too dark, you can adjust the exposure compensation dial on the camera. Usually, the adjustments in exposure can be made in $1/3$-stop increments. It will be trial and error as you make an educated guess of how much more exposure is needed, but a good starting point would be +2/3. From there, you can take another shot and see if you like the results. If you don't, tweak the exposure either plus or minus until the exposure is perfect. (For more on exposure compensation, see page 83.)

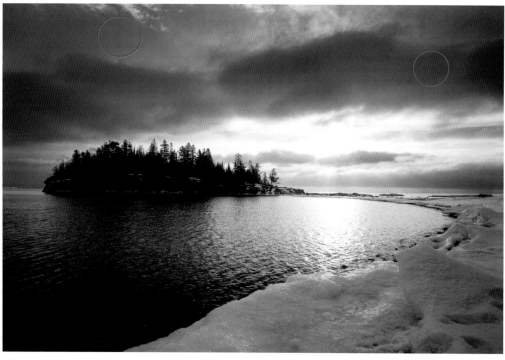

4.9

left
If you learn to correctly identify middle-toned areas in your photos, you can always take accurate light readings using your camera's spot-metering mode.

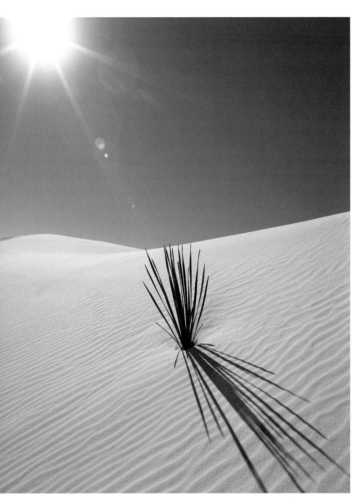

4.10

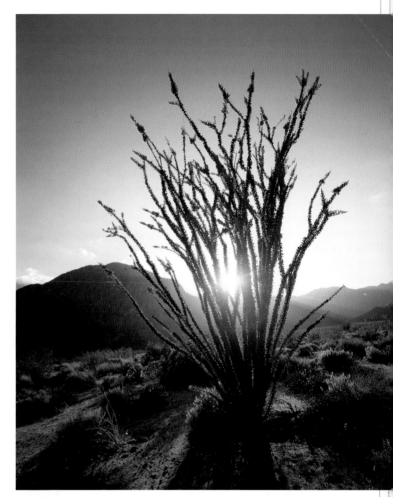

4.11

Lens Flare

One of the unfortunate side effects of including the sun in the frame is the lens flare that sometimes results. It looks like hexagonal, discolored shapes cutting across your picture. Their size and placement depend on the lens you are using and the angle of the lens axis to the sun. If the sun is just outside the frame, you can use either a lens hood or your hand to block the light from striking the front glass surface of the lens, which will often prevent the flare. However, if you can see the sun in the picture, then the flare is impossible to eliminate unless you partially block the sun with some element in the photograph or you use Photoshop in post-processing to clone it out.

You can see in photo **4.10** (above, left) that there is some lens flare. It does add to the idea that the light from a harsh desert sun is intense, but it is distracting because it is magenta and clearly defined—it draws the eye away from the stark landscape. Before I would print this, I would use Photoshop to clone it out with the Healing Brush. In the case of photo **4.11** (above), the ocotillo cactus partially hid the sun, thereby eliminating the lens flare.

Backlighting

In addition to adding a dynamic element to a composition, sunshine offers other benefits in photographs. Some of the most beautiful and artistic types of lighting become available to you. Rim lighting and backlighting (or transillumination as it is sometimes called) completely transform subjects from being ordinary to extraordinary.

In nature, rim lighting outlines tree branches, leaves, and the edges of rocks. Photo **4.12** (below) was taken in Monument Valley, and the sun illuminated the foreground tree beautifully with rim lighting. Had this been lit from the front, the photo would be nice, but it wouldn't have the artistry that you see here. When shooting pictures like this, it is always a balancing act between how bright the highlights should be and how dark the shadows are. Ideally, you want as much detail in all areas of the image as possible. In photo **4.13** (opposite, top left), I added

just enough exposure so the elk wasn't a complete silhouette, but in doing so, I sacrificed some of the sun's definition. In other words, the whole scene had to be lightened, including the sun, which as overexposure does, caused a loss of detail. You can spot this sort of thing by looking at the LCD monitor. It can be hard sometimes to see detail in the monitor in bright sunlight, though, so it can be helpful to carry with you a 4x loupe that covers the glass and enables you to see more detail.

Transillumination is when light comes through translucent things, such as leaves, fabric, dust, fog, water spray, and smoke. In photo **4.14** (opposite, bottom), the leaves in the sequoia forest seem to be glowing from the sunlight. That's what makes this picture so compelling. Similarly, in the geyser shot, taken in the geothermal area of Rotorua, New Zealand (**4.15**, opposite, top right), the composition is dramatized by the backlighting. Notice that I exposed this picture for the water and the sky (as opposed to the foreground). This makes the shape of the column of water more defined, and at the same time, preserves detail in the transilluminated areas of the water. This kind of exposure can be accomplished easily by using the exposure compensation feature on the camera (see page 83); try taking several shots, each with a different exposure compensation value, and at least one should get you the qualities you're looking for.

left
Rim lighting is one of the most beautiful types of lighting. It adds a magical quality to landscapes, portraits, cityscapes, and many other subjects.

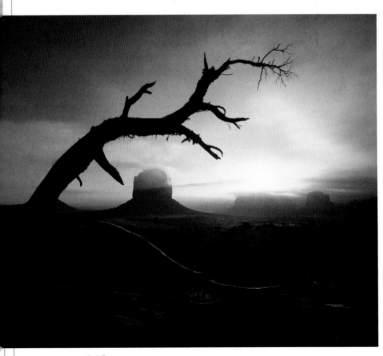

4.12

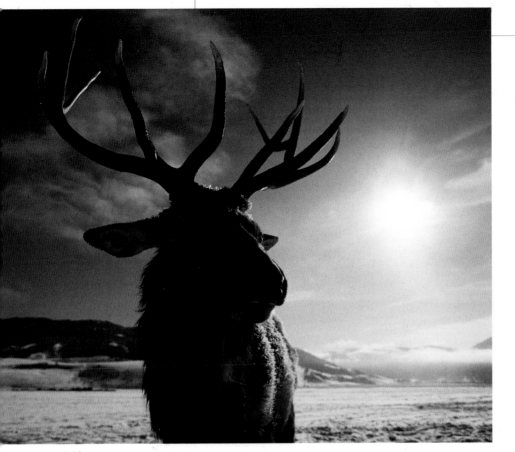

4.13

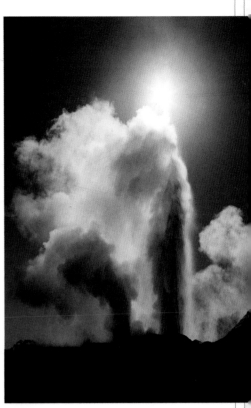

4.15

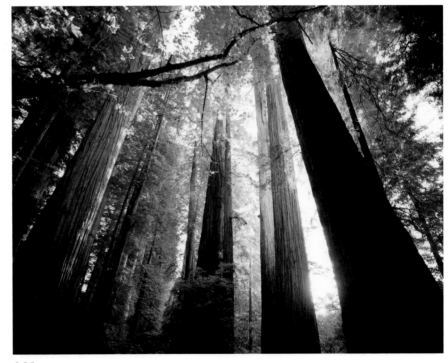

4.14

this page
The closer the sun is to the horizon, the more beautiful the lighting will be. Contrast is minimized, lighting is golden, shadows are long, and texture is pronounced.

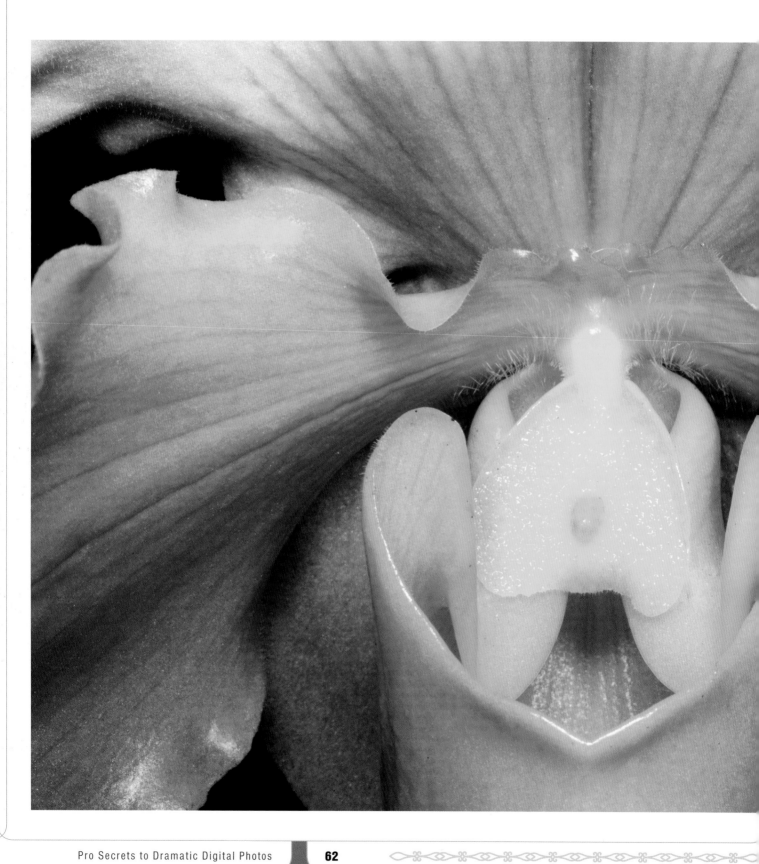

A fun way to create photographs with tremendous impact is to fill the frame with small and intriguing subjects. It will be a source of tremendous satisfaction for you because you'll be revealing the beauty and fascinating detail in things that most people never take the time to notice. More than any other aspect of photography, shooting close-ups has really taught me to see.

Photographing very small subjects calls upon two skills. First, your artistry—when it comes to things like lighting, background, depth of field, composition, and of course, the subject—is vitally important. Second, your knowledge of the technical aspects of shooting close is no small matter. This chapter aims to help you develop both of these skills.

Chapter Five

GET UP CLOSE AND PERSONAL

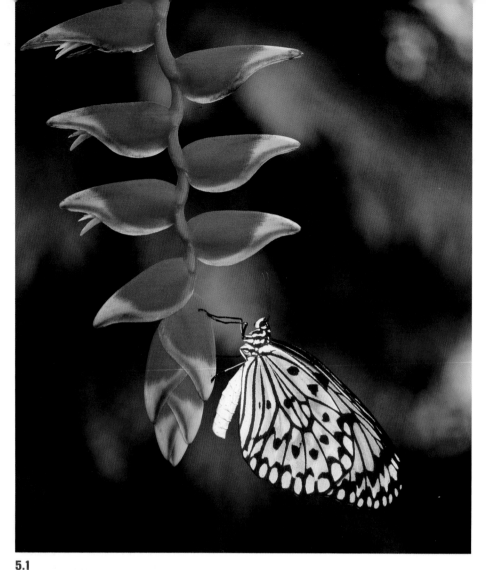

5.1

Macro photography is all about the detail, and
if you are going to shoot close-ups you need
two important things: a tripod, and a small lens
aperture. Selective focus (which means one part
of the subject is sharp while the other parts are
significantly out-of-focus) is a creative technique
at times, but in a large majority of macro shots,
the viewer wants to see the beautiful detail in
your subjects. Just remember that the closer you
get to your subject, the more depth of field you
lose. Therefore, small lens apertures become
critically important. (See the section later in this
chapter, entitled "Depth of Field Issues," for more
information.)

First and foremost, you've got to decide how
you're going to go about getting close to your
macro subjects, so let's look at the equipment that
is available. There are several ways of focusing
closely on small subjects. The method you choose
will be a function of cost, convenience, weight, and
the space you have available in your camera bag or
photo backpack.

Macro Lenses

Many photographers find that the most convenient
way to focus closely on small subjects is to use a
macro lens. If you don't already own a lens with
macro capability, this requires you to buy a new lens.

The cost can be surprisingly low as lenses go, however. For example, I use a 50mm f/2.5 Canon macro lens that cost about $299 at the time of writing. It is very small and light and that's why I travel with it. It takes up very little room in my photo backpack, and it is so light (it weighs just 10 ounces / 283.5 g) that I hardly notice its presence.

Some lenses are designated as "close focusing," which means that you can focus close to small objects, but not as close as you can with a true macro lens. Some of these lenses are even called macro lenses (as mine is), but a true macro lens will allow you to focus closely enough to give a 1:1 magnification ratio. For example, if you were shooting a small frog, one of these close-focusing lenses would enable you fill the frame with the entire frog, but a true macro lens could fill the frame with just the frog's eyes.

Macro lenses are defined by their focal length and by their maximum aperture, as other lenses are. In addition, the amount of their magnification is given. For example, the Canon 50mm f/2.5 macro has a 1:2 magnification. This means that the image on the sensor is $1/2$ life size. If a lens is 1:1, then the image on whatever sensor the lens is optimized for is exactly the same size as it is in reality. (We can't see the image on the sensor until the digital file is opened on a computer monitor. In the past, we used to measure the magnification by comparing the actual measurement of the object with its size on a slide or negative once we developed the film. So, by extension, I refer to the size of the subject on the sensor.) To help you visualize this, if you opened up the image file on your computer and reduced its size on the monitor to the exact size of your camera's sensor (23 x 15 mm for the majority of D-SLRs), the image would be exactly life size

if you had taken the photo at the lens' closest possible focusing distance.

Macro lenses are not limited to macro work. They can also be used to shoot landscapes, people, architecture, pets, and many other subjects. Some photographers prefer a telephoto macro, such a 100mm or a 200mm. These lenses can be used as medium telephoto lenses for portraits, wildlife, architecture and so on, but they also focus very closely so you can fill the frame with small subjects. This kind of versatility can make it easier to justify buying a new lens. What are the main differences between the normal macro and the telephoto macro lenses? There are several important distinctions that you will need to consider when shopping for (or using) a macro lens.

First, a major advantage of a 50mm macro lens is that it takes up less room in your camera bag, and at the same time, it also has a larger lens aperture than most telephoto macro lenses. For macro work, a large aperture isn't too important because usually (although not always) you want complete depth of field and therefore it is the smaller lens openings that are used more often. However, for normal shooting, a large lens opening is obviously an advantage because, among other reasons, it allows you to get away with not using a tripod in relatively low light. The typical telephoto macro lens has a maximum aperture of f/4 or f/4.5.

Second, the distance from the lens to a macro subject when the lens is focused at its closest focusing distance (referred to as the working distance) is shorter with a 50mm macro than with a telephoto macro. This is important in many situations. A telephoto macro allows the photographer to stand back several feet so that a close approach isn't necessary, which is a huge

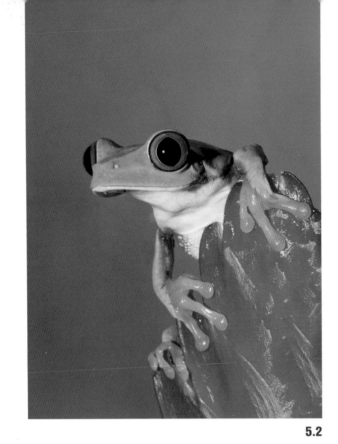

advantage if your subjects are skittish. This same issue can arise when photographing a close-up of any difficult-to-approach subjects like lizards, frogs, all kinds of insects, and poisonous creatures like snakes or scorpions. By standing back a few feet from a red-eyed tree frog (**5.2**, left), I was able to get this classic pose. If I had been using a 50mm macro, I wouldn't have been able to fill the frame like this without getting so close that I scared it away. When shooting flowers or subjects that aren't afraid of a close approach, a 50mm macro is fine. The exotic tulip that I photographed in the famous Keukenhof Gardens in Holland (**5.3**, below) was taken with a 50mm macro.

Third, telephoto lenses have less depth of field than "normal" (50mm) lenses. Sometimes this

5.2

top

Notice how plain the background is behind the frog. The background is an out-of-focus photographic print of foliage. This directs all of the attention to the subject.

left

Use complete depth of field to capture the beauty of flowers in sharp detail. This means that a tripod is essential because it allows you to use very small lens apertures.

5.3

is an artistic advantage, while at other times, it's a problem. Out-of-focus backgrounds are complementary to nature subjects as you can see in photo **5.4** (right). Nothing competes with the frog or takes our attention away from it. The longer the focal length of the lens, the softer the background will be. In other instances, shallow depth of field works against you. In the close-up photo of the baby chimpanzee (**5.5**, below), the out-of-focus hair of the mother takes away from the photo. I feel it is distracting and unattractive.

Finally, telephoto macro lenses have a greater sense of compression, typical of all long lenses. This kind of effect is appealing to many photographers. In photo **5.6** (below, right), the tulips seem more stacked, or compressed, than they really were because they were photographed with a 200mm macro.

5.4

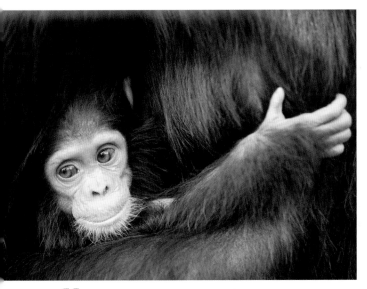

5.5

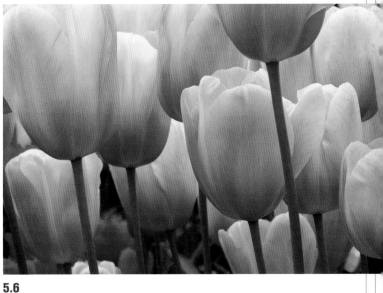

5.6

Diopters

A diopter is essentially like a magnifying glass that screws onto the front of a lens, allowing you to focus closely. Kits are available that include a set of three diopters, where you either use one at a time or stack them for increased magnification. The quality of the glass is good but it's not as good as your lens by itself. Instead of an off-brand kit, I would suggest using the Canon 500D two-element diopter. In spite of the Canon name, it will fit any lens made by any manufacturer. This is a very sharp close-up lens, and I've used it for years with excellent results.

Diopters, like filters, are purchased by the size of their diameter, which is marked on the outer edge of the filter. They screw into the filter threads of the lens mounted on the camera. Each lens has a filter size, and this number can be found somewhere on the lens itself (see **figure A**, below). The larger the filter size, the more expensive the diopters will be. Diopters are quite inexpensive compared to regular lenses, though.

The advantages that the Canon 500D diopter offers are several: First, they are relatively inexpensive—a 72mm filter size is only about $125. This is a great way to get into macro photography. Second, it is small and light compared to a macro lens. It takes up virtually no space in your camera bag.

Another significant advantage is that there is no light loss when you use a diopter, as there is with extension tubes (see next section). A reduction in light means that a longer shutter speed is required, and with small subjects such as insects, or perhaps flowers moving in a slight breeze, your pictures can easily be blurred.

Finally, diopters can be used on a variety of lenses. Usually, they are used on a normal or medium-telephoto focal length. Using it on a wide-angle would make the working distance so small—less than an inch—that it's not practical, because the camera and lens would cast a shadow on the subject. Any medium telephoto can be turned into a telephoto macro lens using a diopter, and if you use a zoom lens with a range of focal lengths, it too can be used as a macro lens for focusing closely.

The only disadvantage of using the 500D diopter is that you are introducing more glass into the optical system. Even though it's sharp, it may not be as critically sharp as the lens by itself, particularly around the outside areas of the frame. I have never felt this was a problem, though. I have enlarged photographs that were taken with the diopter to 24 x 30 inches and sold them in galleries, and I never had any complaints about lack of sharpness. Photo **5.7** (opposite) was taken with a medium telephoto and the 500D. I was standing four or five feet away from this captive hornbill in Papua New Guinea.

figure A

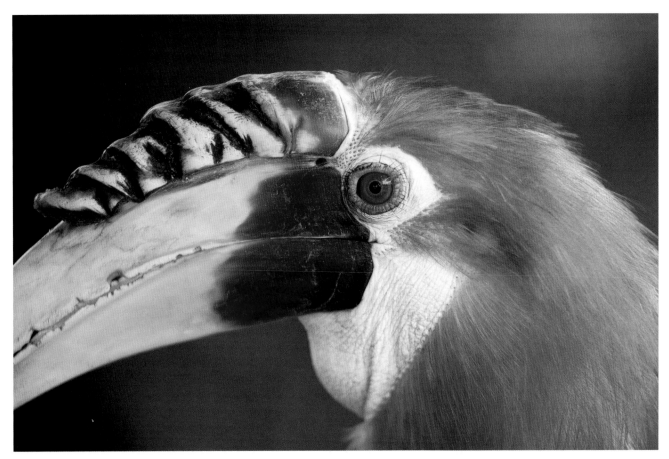

5.7

Extension Tubes

An extension tube is simply a hollow metal tube that is machined to fit between the camera body and the lens. By putting the lens farther away from the body, magnification is increased and you can then fill the frame with small subjects. Tubes often come in sets of three, where each one is a different size. Just like diopters, they can be used individually or in combination for greater magnification.

The important advantage to using a set of extension tubes is that no additional glass is combined with your regular lens. Therefore, there is no possibility of the image quality being degraded in any way. However, the disadvantage is that extension tubes cause a loss in light. If your subject isn't moving and you are shooting from a tripod, this doesn't matter, but it can be a problem if the subject or scene requires a fast shutter speed and/ or if you're handholding the camera.

Extension tubes have one other significant advantage. Used with a telephoto lens (or telephoto zoom), they instantly turn the lens into a telephoto macro. This gives you the greater working dis-tance, extremely blurred backgrounds, and strong sense of compression that I discussed earlier.

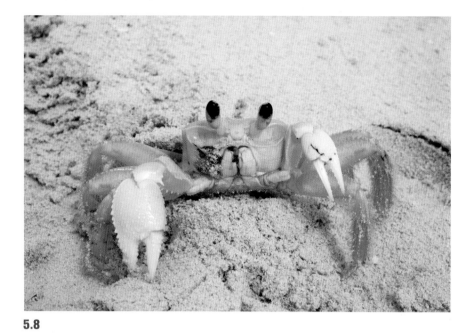

5.8

left
Photo 5.8 was taken with a 70-200mm zoom plus one extension tube, and I was able to shoot from about four feet away. The greater working distance prevented the crab from being frightened away.

below
The vervet monkey in 5.9, however, was closer to me than my lens by itself could focus, so I used an extension tube in order to get a closer focusing distance.

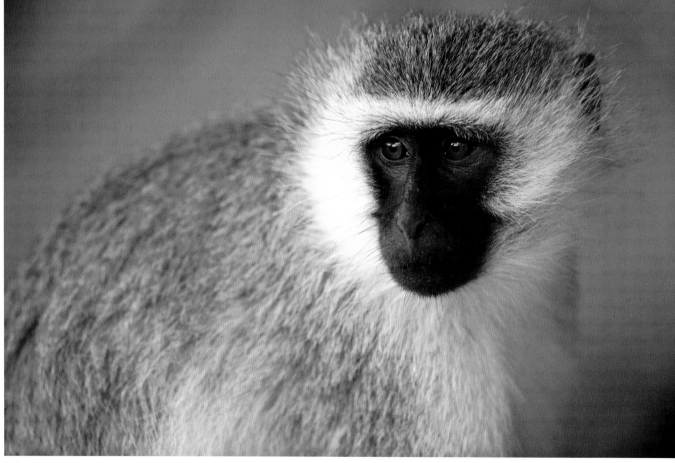

5.9

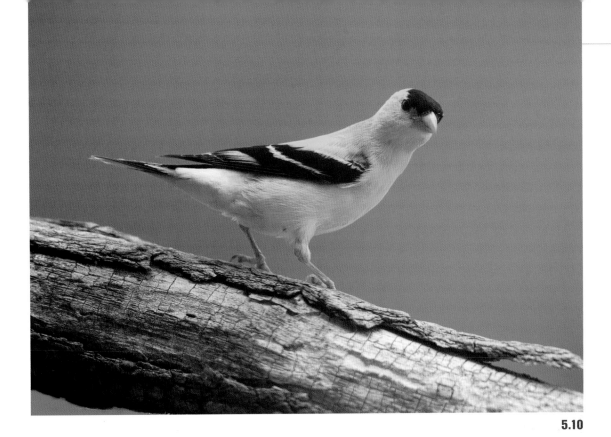

5.10

Another advantage of extension tubes that few photographers know about is that they can be used in conjunction with long telephotos to turn them into close-focusing lenses. All lenses have a minimum focusing distance. If a subject is closer to the lens than this minimum distance, the subject will not come into focus. For example, my 500mm f/4 telephoto can't focus closer than 14.8 feet. However, with an extension tube between the lens and camera body, that distance can be cut down to 6 or 7 feet, and with a second tube, I could focus even closer. I captured the black-faced vervet monkey in photo **5.9** (left) as it sat about eight feet from my vehicle in East Africa. I used the 500mm lens because I wanted a frame-filling close-up, but in order to focus that closely, I had to place an extension tube between the lens and body. This made the depth of field extremely shallow, of course, but my goal was to capture an intimate close-up. As long as the eyes are tack-sharp, other parts of a subject—human or animal—can be soft. Notice also the eye-level perspective I used. Instead of shooting downward out of the roof hatch, I chose to photograph the monkey from a side window. This made the frame-filling composition seem more intimate.

Similarly, I photographed an American goldfinch (**5.10**, above) at my bird feeder outside my office window using the same technique. Because the bird was so small, I used my 500mm lens in conjunction with a 1.4x teleconverter giving me an effective 700mm lens. The bird was only about 8 or 9 feet away so I had to use an extension tube to focus on it. I placed the tube onto the camera body, then the teleconverter, and then the lens. I shot this right through the glass and the picture turned out great. This isn't technically macro photography, but it's another application of extension tubes that basically does the same thing—it allows you to fill the frame with a small subject. I consider these invaluable and I carry them as standard equipment in my camera backpack.

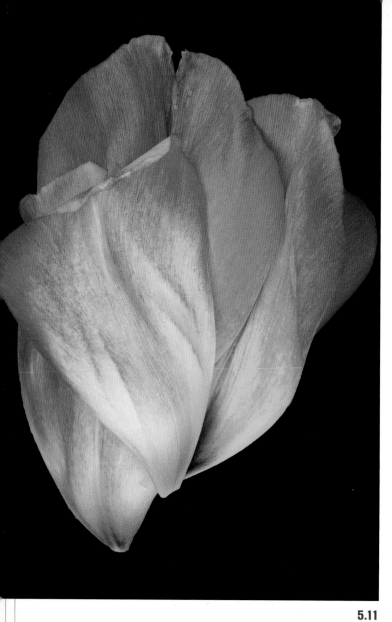

5.11

Bellows

A bellows system (**figure B**, below) is very similar to extension tubes in that it fits between the lens and camera body and it doesn't introduce additional glass. The difference is that the distance between the lens and the body is continuously variable. This gives you the ultimate in control over the magnification, plus other factors such as depth of field and perspective. Bellows can be much more expensive than extension tubes (however, you can find inexpensive models on ebay.com), and they are fairly large even when collapsed, but they offer all kinds of creative possibilities. It is not convenient to carry them while traveling or hiking, but for studio work or for using your car as a base, they work great. I photographed photo **5.11** (left) using a bellows system.

Depth of Field Issues

The biggest challenge in macro photography is getting enough depth of field. A tripod is essential for this kind of exacting work because close shooting reduces depth of field dramatically, and as you close the lens down to compensate, the reduction in light forces a slow shutter speed.

The smallest lens apertures you have available are typically f/22 and f/32. Even though these are not the sharpest lens apertures to use, they give you the most depth of field without the aid of post-processing work.

Another technique that helps improve depth of field is to make the back of the camera as parallel as possible with the plane of the subject. If the camera is at an oblique angle, depth of field decreases quite a bit. In photo **5.12** (opposite, top) for example, I placed the camera such that the back of it was parallel with the plane of the rock face. Not all

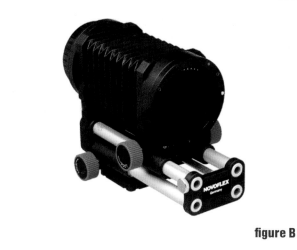

figure B

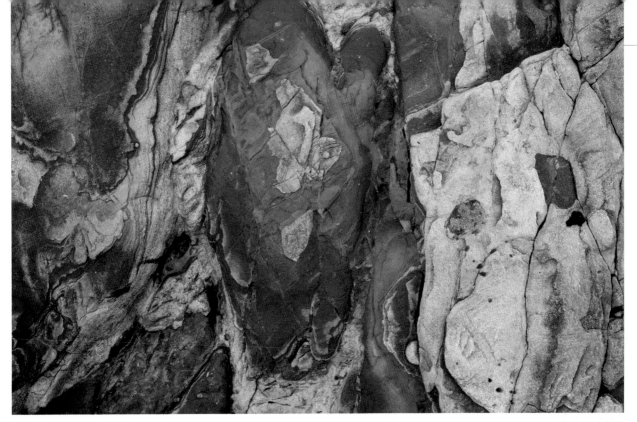

5.12

subjects are that flat, of course, but even with a subject like the orchid in photo **5.13** (right), the depth of field can be increased at least to some extent using this simple technique.

There is another method of achieving complete depth of field, but it is unrelated to photographic principles. Someone has figured out how to achieve complete depth of field irrespective of the lens aperture. Helicon Focus is a software program that is just brilliant! It allows you to combine multiple photographs into one image that is sharp from front to back, should you want that much depth of field. This can be used for macro photography as well as when using a telephoto. What is amazing is that if you use a long lens, you still get the telephoto compression, but everything is tack-sharp from front to back. (See page 119 for more information on this software.)

5.13

above
Intimate close-ups of flowers require, in my opinion, complete depth of field. I believe that is the only way to reveal their beauty.

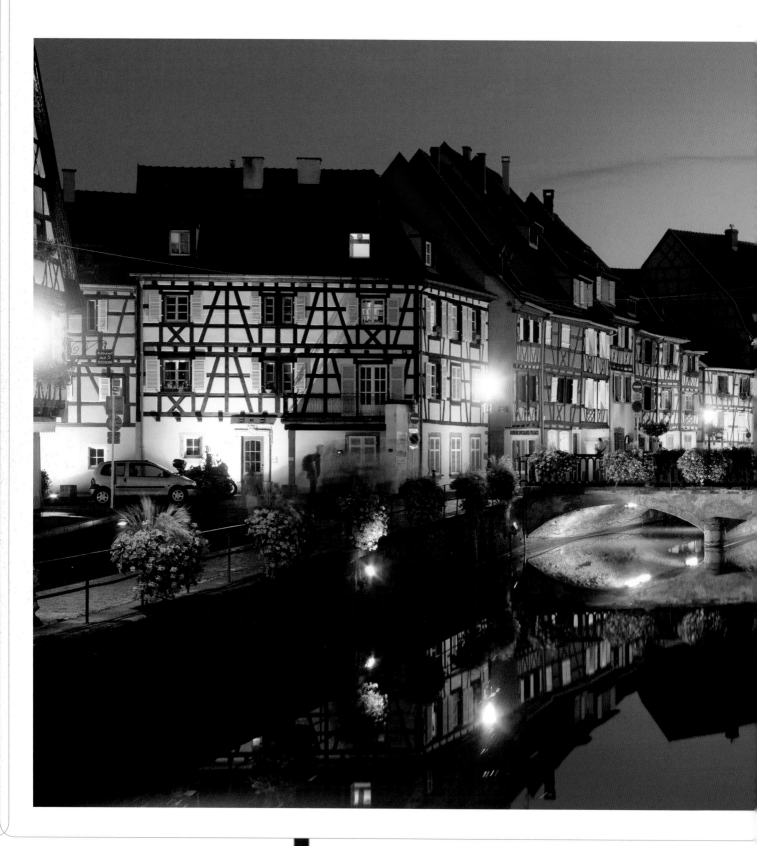

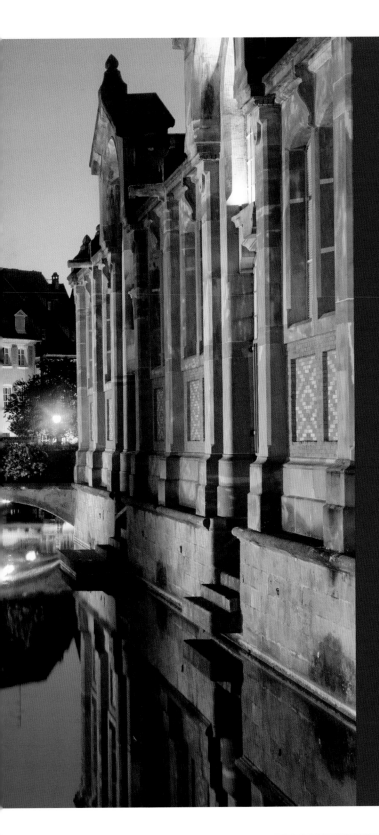

One of the ways you can add drama to your pictures of cityscapes, architecture, amusement parks, bridges, monuments and other man-made structures is to shoot them at twilight. The mixture of the cobalt blue sky with the artificial illumination is stunning, and you will be amazed at the outstanding pictures you will get at this time of evening.

WAIT FOR TWILIGHT

Twilight Time

Before I go on, it's important that I distinguish between twilight and dusk. Dusk is the time after sunset and before twilight. The sky still has some light in it, and if you are shooting the skyline of a large city, you'll see a few lights in the tall buildings. Twilight begins when you can see all the lights in the buildings clearly and the sky has become a deep cobalt blue. If you shoot too early, you won't get the saturated colors that make the picture so compelling. In addition, the sky will most likely be overexposed when you expose for the architecture. At the very least, it won't have the kind of saturation that I feel makes the strongest image.

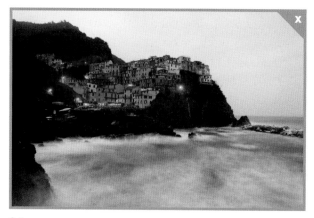

6.1

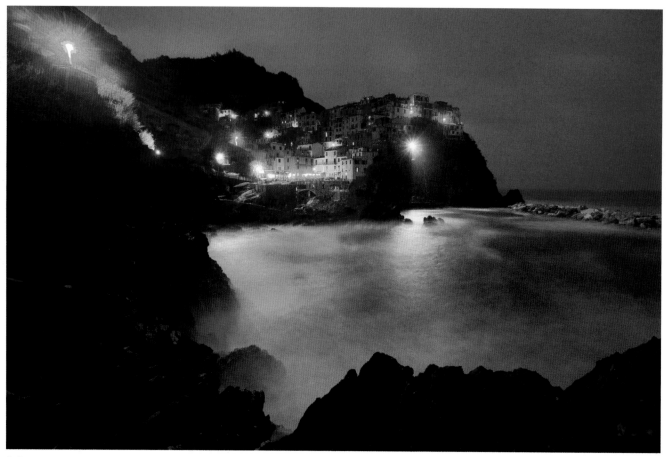

6.2

You can see this difference in photos **6.1** and **6.2** on the opposite page, taken on the Cinque Terra coast of Italy. Photo **6.1** was taken about 20 minutes too early. It is not a bad picture at all—in fact, I like it—but maximum drama with respect to color contrast was achieved when the sky became that deep cobalt blue. Photo **6.2** is much more dramatic.

Twilight is darker than dusk, and that forces you to use a longer exposure. The advantage in doing that, however, is that the lights in the buildings, which don't seem that bright when you look at them, will turn out brilliant in the photograph. The longer exposure time accumulates light to make the illuminated windows appear much brighter than they really are, and this can only happen when it's dark enough so the longer shutter speed won't cause overexposure in the rest of the frame.

I took photo **6.3** (below, left) in Philadelphia about 10 minutes too early for maximum impact. Again, I like the image, but it doesn't have the rich color tones and the powerful contrast that photo **6.4** (below) does. What is also interesting to note is that it doesn't matter if the sky is clear or if it has a thick cloud cover. You will still get the cobalt color that characterizes twilight photography.

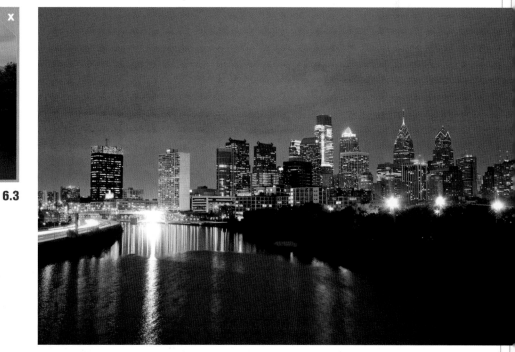

6.3

6.4

this page
Wait until the right time to get the best colors from twilight. If you shoot too early, the pictures won't have the depth of color that you want.

opposite
When shooting at twilight and at night, I recommend focusing manually. Autofocus may not function accurately in low-light situations.

The Tripod Factor

Don't make the mistake of shooting at twilight without a tripod. I cannot stress how important this is. It will be an exercise in frustration, and you won't be satisfied with the results. The reduced ambient light will force you to use a long shutter speed, and you will get a less-than-sharp picture. At best, you can rest the camera on a solid support like a fence post, but it will be hard to angle the camera correctly to get the composition you want.

6.5

Many photographers just bump up the ISO to deal with the diminished ambient light, but that's not a good solution. ISO settings above 400 cause visible digital noise (a grain pattern that shows up as multi-colored specks in the image). Furthermore, digital noise is most noticeable in the shadow areas of an image, and when you shoot at twilight, most of the scene is dark; so, using a high ISO to shoot a scene like that would only make the noise in the shadows even more pronounced. In the past, when we all shot film, graininess of fast films was often considered artistic and sometimes photographers used these films purposely. However, digital noise is decidedly less attractive. In fact, we use programs like Noise Ninga specifically to minimize excessive and unpleasant noise in an image. I prefer to use ISO 200 or less for night photography so I can avoid having to deal with noise altogether.

It is true that some of the newer cameras can handle high ISO settings quite well. At the time of writing, I am using a Canon 5D Mark II, and I've photographed architecture, wildlife, and other subjects at 1250 ISO and I could hardly see any noise at all. My preference, though, is always to shoot at the lowest ISO setting because this gives the least amount of noise possible. If you were to make an 8 x 12-inch print, the difference between ISO 100 and ISO 400 may not be appreciable, but in a much larger print it would be obvious. The difference between ISO 100 and ISO 1600, however, is discernible even in a small print as well as on your computer with no enlargement.

Using a tripod gives you the luxury of using a low ISO, plus you can use as small an aperture as you'd like, allowing you to better control depth of field. The only time a tripod won't help very much is if you are shooting from a boat on the water.

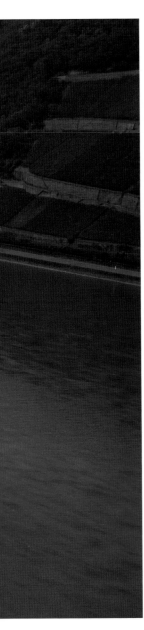

left

Even in the most awkward situations, like the small rocky promontory from which I photographed Rheinstein Castle in Germany, I use a tripod. I practically killed myself getting this picture. In the darkness following twilight, I stumbled and fell about 30 feet down the steep slope through dense, thorny bushes. I landed with bloody arms and legs and, worse than that, I lost two lenses and some other gear because my photo backpack wasn't zipped closed. But, I didn't forget to use my tripod!

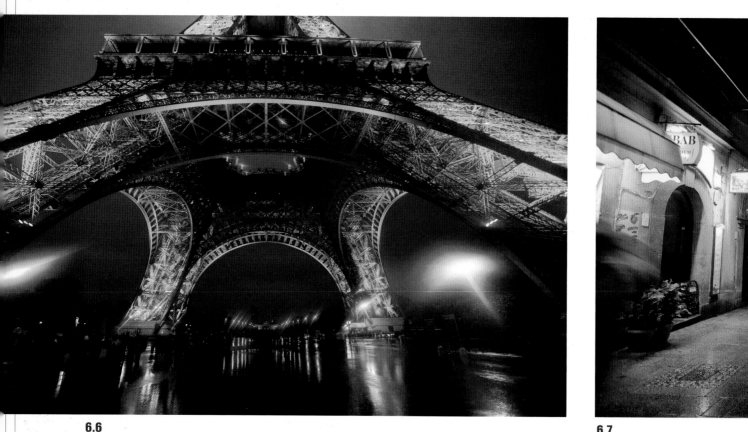

6.6

6.7

Wet Pavement

Shooting at twilight after a rain is ideal. When the cement, asphalt, or cobblestone is wet, it reflects lights and makes the resulting photos so rich and beautiful. Photo **6.6** (above) of the Eiffel Tower is an example. There was a light drizzle and a low fog in Paris that evening, and the glistening pavement adds a lot to this image. The structure itself looks dramatic because I used a very wide 16mm lens (on a full-frame sensor camera).

When I went out to take pictures on a rainy evening in Krakow, Poland (**6.7**, above, right), the rain made the scene beautiful, but I had to constantly dry the front glass element of the lens. I always carry a microfiber cloth for that purpose. I also use a clear shower cap with an elastic band to protect the camera from light rain. In this picture, you can see some lens flare from the street lamps that occurred because of the water drops that fell on the lens in the couple of seconds between the time I wiped the lens clean and when I took the shot. The best-case scenario is to have someone holding an umbrella above the camera.

Best Subjects

As in all aspects of photography, great subjects make great pictures. A three-story office building built in the 1960s or 1970s (when I'm sure that architects competed with each other to see who could design the ugliest buildings) may look better

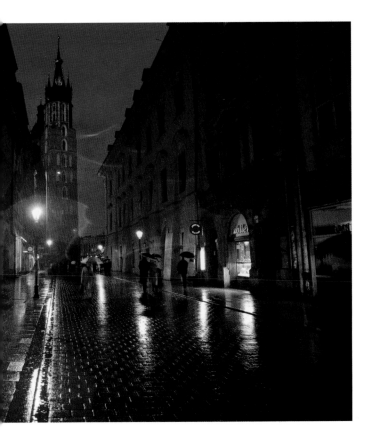

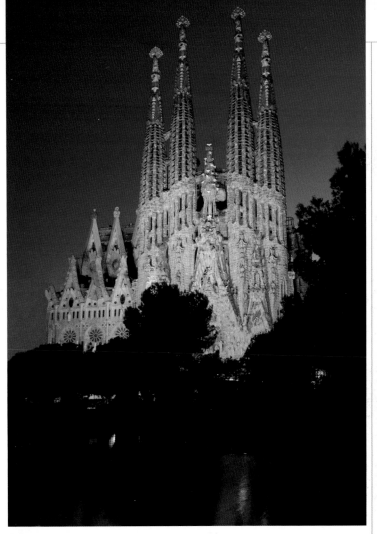

6.8

at twilight than during the day, but it's just not going to make an exciting photograph no matter how good the composition and exposure are. Seek out those subjects that are graphically strong and that are illuminated beautifully at night. Photo **6.8** (above, right) of the famous cathedral by Gaudi in Barcelona and the stunning Disney Theater in Los Angeles (**6.9**, right) are prime examples.

Most large cities in the world have skylines that look great at twilight. It may take time to find the best vantage points, but that's why I always do research online and at tourist shops that sell postcards. The latter shows me the best possibilities. The first time I went to St. Louis,

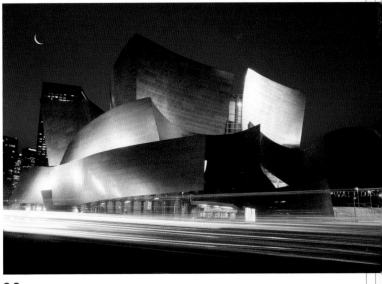

6.9

Chapter Six

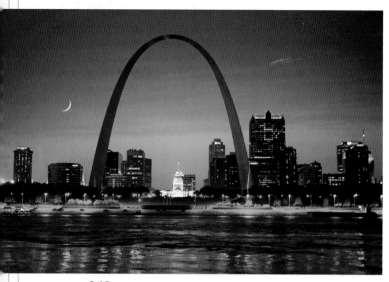

6.10

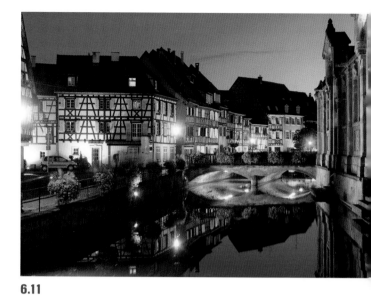

6.11

6.12

for example, I was able to find a great location across the river to get photo **6.10** (top left) because I had seen it on a postcard. I used the same technique in Colmar, a small town in France. I had walked all over the beautiful town taking excellent shots, but I didn't see the great composition in photo **6.11** (above) until I saw a postcard of it. I bought the card and then asked the vendor how to get to this particular vantage point.

I try to gain access to very tall buildings whenever I can because the aerial point of view over large cities is usually spectacular. In the daytime, these views are wonderful to see, but photographically, they aren't very inspiring. However, at twilight, they can be truly breathtaking. Photo **6.12** (left) was taken from the 94th floor public observation deck in the John Hancock building in Chicago. I had to shoot through glass, but the picture came out extremely sharp. The biggest challenge was eliminating reflections in the window from interior lights, so I put the lens of my camera up against the glass and cupped the end of the lens barrel with my hands.

The Exposure Challenge

The exposure meter in your camera doesn't react to twilight and night scenes as it does when you shoot at other times of the day. Meters are programmed to interpret scenes with every lighting condition as middle gray (see pages 57-58 for more information). This means that when you shoot a scene like in photo **6.13** (right) of the castle in San Marino (a tiny sovereign enclave within Italy), the meter tries to make it middle-toned. Since this scene is actually darker than middle-toned, the resulting picture will be too light. It will in fact be middle-toned, but that's not what you want. You want to capture twilight lighting, which is dark.

Back when I still shot film, I had a twilight exposure formula that worked all the time. It was 10 seconds at f/8 with 100 ISO. We didn't have the advantage of seeing our exposures immediately, but now with the instantaneous feedback on the LCD, it's a simple matter of taking a picture, looking at the result, and tweaking the exposure. To over- or underexpose the picture, you can just use the exposure compensation feature on the camera. Most digital cameras have this, and if you don't know where it is on yours, consult the camera manual and you'll find it. When it is active, you'll see a menu that will look similar to the one shown in **Figure A** (below).

Each dot usually represents ⅓ f/stop. As you rotate one of the dials on the camera, the cursor moves to the right or the left, and this affects the exposure. If you take a picture that is too light, for example, you could underexpose the image by a certain amount—say ⅔ stop—and shoot again. To do this, the cursor would have to move two dots to the left. If the image still needs adjusting after you study the result on the LCD monitor, simply make another movement either right or left until you like the result.

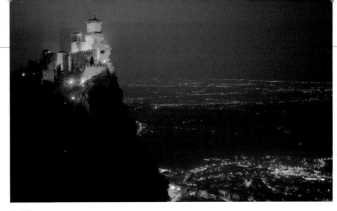

6.13

Technical issues

It is obviously important to use a tripod. There are a few other things that I feel are important to do to insure your pictures are tack-sharp. First, you need to use the mirror lock-up feature. Every time you take a picture, the mirror in the camera has to flip up out of the way to allow the light entering the lens to reach the sensor. This movement can introduce a small amount of vibration, which, in turn, can cause a degradation in sharpness. By locking up the mirror, this problem is eliminated. Refer to your camera's manual if you do not know how to use this feature.

Second, you need to use a remote, a cable release, or the self-timer on the camera to trigger the shutter. Instead of pushing the shutter button, which can jar the camera just enough to soften the picture, any remote method of taking the picture prevents this from happening.

Finally, how you use your tripod is important. Many photographers raise the center column to a comfortable height, but that makes the tripod less stable. I suggest lowering the center column even if that means you have to bend down to look through the viewfinder. I like to put all the odds in my favor with respect to taking sharp pictures.

figure A

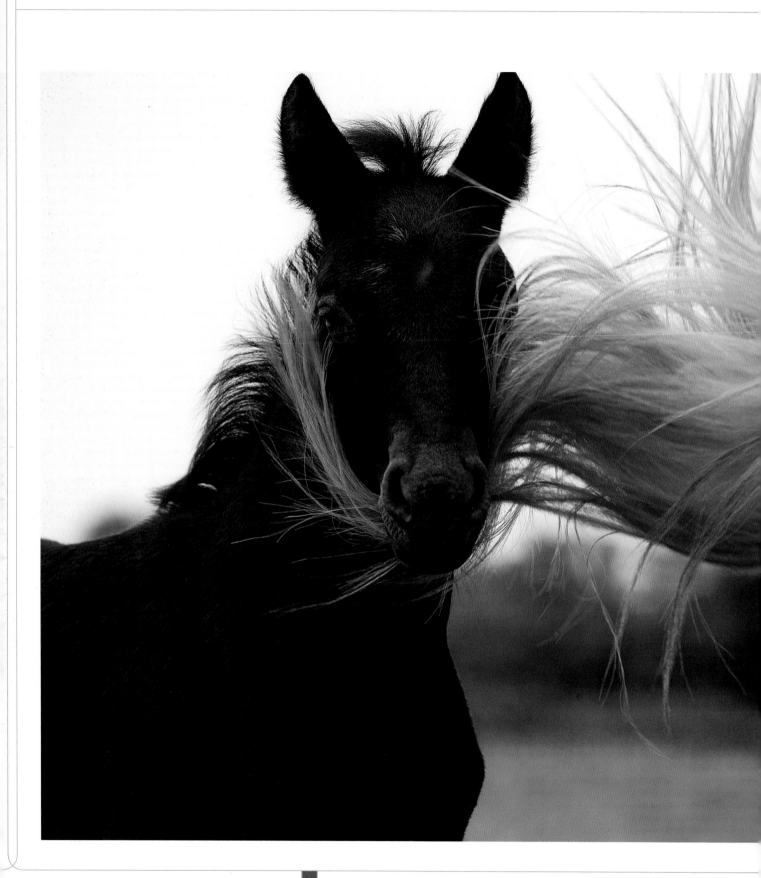

Cameras can do what the human eye cannot. They can freeze motion in the tiniest fraction of a second, allowing us to examine dynamic moments at our leisure and to see things that otherwise would elude us completely. In addition, using long exposures with moving subjects, cameras can blur and blend colors and forms in the most artistic way. Motion becomes an art form. What a wonderful thing photography is!

CAPTURE MOTION

Three Ways to Show Movement

The wonder of photography, however, is limited in that motion in a still photograph can only be implied. We can only suggest a subject is moving and let the viewer imagine the rest. There are three techniques we can use to show that a subject (or the camera) was moving when the picture was taken:

1 Using a fast shutter speed, we can freeze movement with tack-sharp clarity, and the viewer's everyday experience tells them that the subject was moving. Photo **7.1** (below) is an example. We know, because of the position of the horses' legs and the splashing water, that they were running through the marsh. This picture was taken at $1/640$ second.

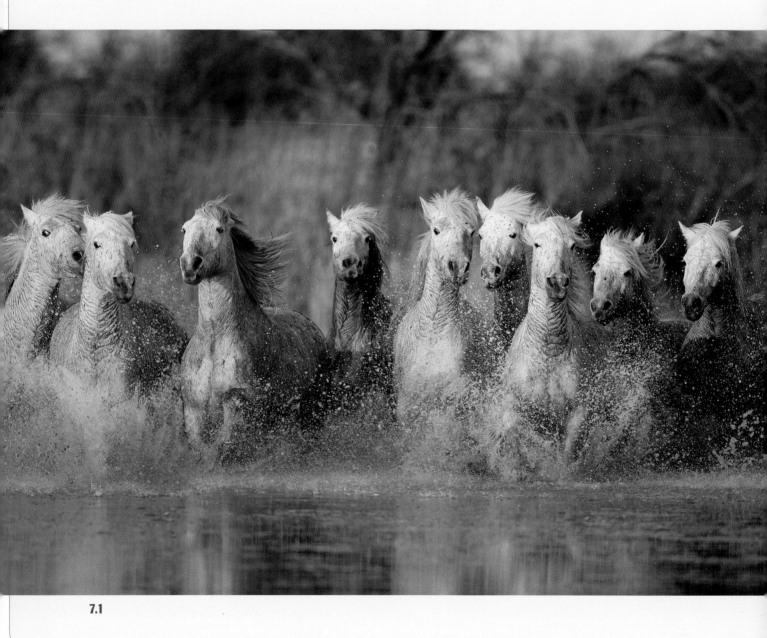

7.1

2 We can use a long shutter speed and allow the movement to blur, and the viewer's eyes automatically perceive that the subject was moving. I took photo **7.2** (right) at a bicycle race, and as the competitors passed me I followed them with the camera, using a shutter speed of $\frac{1}{6}$ second.

3 We can combine both effects, photographing a scene that contains both moving and stationary elements, as in this photo of the Roman Coliseum (**7.3**, below).

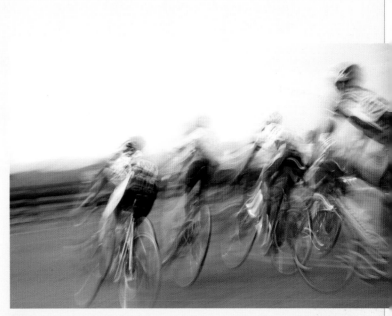

7.2

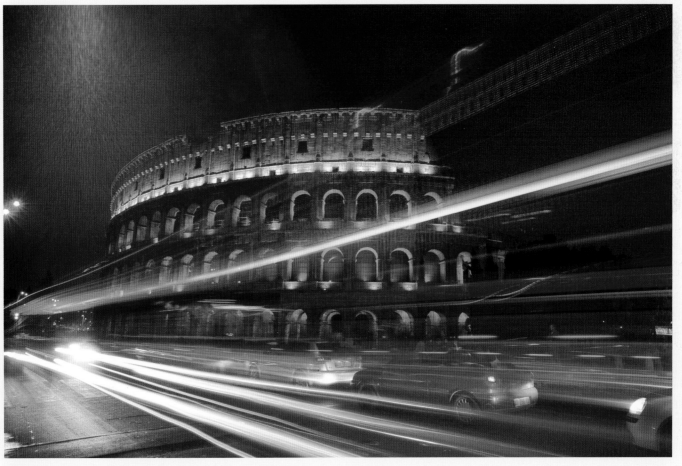

7.3

Chapter Seven

Freezing Subjects in Motion

The shutter speed you use to freeze moving subjects will depend on several factors: the speed of the subject, the direction of movement in relation to the camera, the focal length of the lens, and the distance of the subject to the camera.

Most important is the speed of the subject's movement. For example, the flick of a horse's tail (**7.4**, below) requires the shutter speed to be fairly fast, but not excessively so. In this case, I used $^1/_{1000}$ second, although I'm sure that $^1/_{500}$ would have produced just as sharp a picture. The action I captured in the Civil War battle reenactment (**7.5**, below,

right) required a shutter speed of only $^1/_{250}$ second, because the soldiers weren't moving very fast. On the other hand, in order to show the detail in the wings of a hummingbird, photo **7.6** (right), I had to use an incredibly fast speed—$^1/_{16000}$ second. This wasn't achieved by literally using that fast a shutter speed, however. I had to use a flash to simulate a shutter speed that fast, because cameras don't have shutter speeds that high. By reducing the power output to $^1/_{16}$ power on the four flash units used for this picture, I was able to shorten the flash duration (the actual time the light inside the flash is on during the exposure) to $^1/_{16000}$ second.

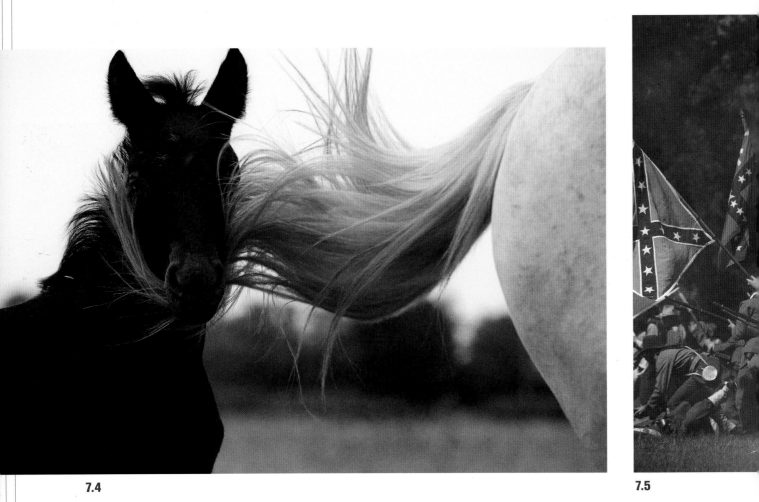

7.4

7.5

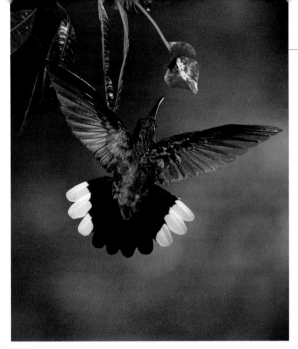

7.6

If you aren't sure how fast a shutter speed is required to freeze a moving subject, err on the side of maximum speed. In other words, use the fastest shutter speed you can. This will depend on how much light you have and the lens aperture you're using, though. If the day is overcast and the light level is relatively low, you won't be able to use a shutter speed as fast as you may want. Raising the ISO is a solution, although since it's a good idea to use low ISO settings (like 100 or 200) to maximize picture quality and minimize digital noise, you will have to strike a balance between the speed of the shutter and the ISO setting. If you have a lot of light in an outdoor environment, like I did when I photographed a Sikh festival in India (**7.7**, below), then you can use as fast a shutter speed as necessary to freeze the movement in your scene.

7.7

However, in shooting the wolves playing in the snow (**7.8**, below) under a dark, overcast winter sky, I had to raise the ISO to 800 to allow a fast enough shutter speed to render the animals sharp. Even so, my $1/125$ second wasn't quite fast enough to give me as sharp an image as I wanted. But I had to make that compromise, because ISO 800 was as high as I wanted to go before too much digital noise degraded the image.

To a lesser degree, you will also need to consider a few other factors when you intend to freeze motion in a scene, including your lens' focal length. You must think about focal length because when your moving subject is greatly magnified, as it would be with a long telephoto lens, the speed of its movement is magnified, too. So, any time you change to a longer lens, be sure to use a faster shutter speed. For similar reasons, the camera-to-subject distance is also important to keep in mind, because when the subject is far away, it appears to be moving slower. As it gets closer to the camera, it seems to speed up. So, to freeze a moving subject close to the camera requires a faster shutter speed than if it were farther way. And finally, remember that the subject's direction of movement in relation to the camera is a factor in how its motion is captured. A subject

7.8

moving toward or away from the camera will not require as fast a shutter speed as one that moves across the frame (assuming all other possible variables are the same, i.e., the camera is not panned with the subject, lighting is the same, etc.).

Slow Shutter Speeds

One of the simplest of all photographic techniques to master and enjoy is the use of a slow shutter speed to imply motion in a still photograph. Color and shapes become abstracted in artistic ways, and although you can't predict exactly how the pictures will look, much of the time, the results are striking. Part of the fun is the unpredictability of the technique. Even after 40 years of photography, I can previsualize only the idea of what will come from this technique, but the actual pictures are always a surprise.

In choosing a slow shutter speed to imply motion, I suggest starting with $1/8$ second. After you take the picture, check the LCD monitor and adjust the amount of blur you get by changing the shutter speed if necessary. This is one of the big advantages of shooting digital—you can immediately see what you get, and then if you need to tweak the results, it's easy to do.

The two photos I took at a Christmas parade in San Juan, Puerto Rico, **7.9** and **7.10**, at right, were shot at $1/8$ second and $1/4$ second, respectively. I started with $1/8$ second and liked the results, but then I went for a much more abstracted look by slowing the shutter down even more. I ended up with a picture that looks more like a painting than a photograph. Notice how I filled the frame with color. I eliminated the street, the crowd, and the vehicles parked behind the dancers so the colorful, painterly rendition of the movement was the only thing in the frame.

7.9

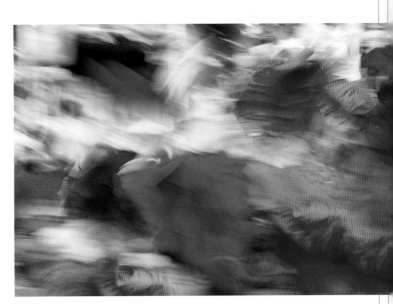

7.10

above
Long exposures in combination with brilliant colors produce wonderful abstracts. By experimenting with various shutter speeds, you can define how recognizable your subject will be.

One of my favorite techniques is panning with a moving subject and using a slow shutter speed. The subject itself is blurred, but less so than the background. The African pelican I photographed at Lake Nakuru in Kenya, (**7.11**, below) is an example. The lake was filled with literally millions of flamingos, and the blur of pink behind the pelican is the abstraction of all those birds. I used a shutter speed of $1/25$ second because the 500mm telephoto lens I was using has a narrow angle of view and the bird appeared to be flying rapidly across my field of vision. This allowed the image of the bird to blur, but enough definition was retained so we can see clearly what it is. The flamingos were blurred beyond recognition, and that's what I wanted. A similar technique was used in photographing a galloping horse in France, **7.12** (bottom).

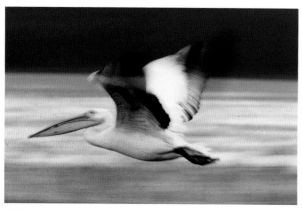

7.11

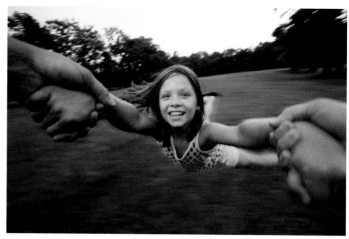

7.13

I used a novel approach to getting the same kind of effect in photo **7.13** (above). My neighbor was spinning his daughter, Grayci, and I held my camera with a 16mm lens in front of his chest and spun with him. The image of Grayci is relatively sharp compared to the background. The usual slow shutter speeds I use blurred the image too much, so I tried $1/125$ second. This gave me the kind of image I was looking for.

There are many variations on this kind of theme. For example, **7.14** (opposite, top right) shows autumn foliage in New England blurred when I used a $1/8$-second shutter speed from a moving car. I was a passenger and took the pictures through the front windshield. I used the "shotgun approach" to shooting here, in that I quickly took a lot of shots and only a few were good. Another way to abstract movement is to use the wind. When I photographed poppies in California (**7.15**, opposite, middle), I used a tripod and let the wind do the rest. I purposely used a long exposure—one second in this case—to allow the flowers to leave an impression of color as they swayed with the breeze. Instead of moving the camera past the subject, the poppies in essence moved back and forth past the camera.

7.12

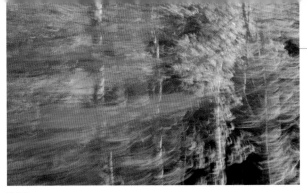

7.14

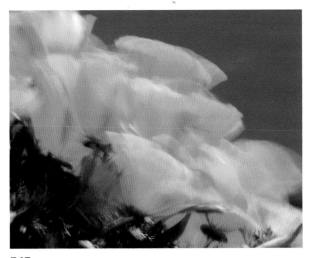

7.15

Blur and Sharpness Combined

When I photographed in an amusement park in San Diego, California (**7.16**, bottom left), I used a tripod and a ¹/₈ second shutter speed. The tripod insured that the rollercoaster structure was sharp, while the long exposure allowed the car to blur. This juxtaposition of a blurred subject against a sharp background makes a compelling image.

You can get a similar effect using flash. The short flash duration freezes a moving subject, and if you use a long shutter speed at the same time, it allows the same subject to also create a blurred impression in the picture. I used this technique in photographing ballroom dancers (**7.17**, below, left). I used ¹/₂₀ second in this case. I experimented with slower shutter speeds and didn't like the results. I used a similar technique in **7.18** (below, right), of a costumed participant in the carnival in Venice, although in this case, after the flash fired, I moved the camera toward an illuminated window display. The streaks of light are superimposed over the subject because I used a ¹/₂ second exposure, which gave me enough time after the flash went off to swing the camera toward the lights.

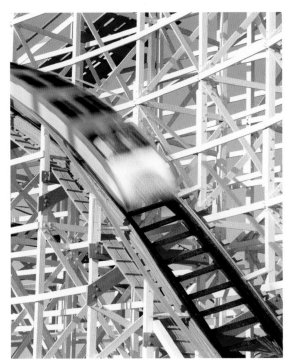

7.16

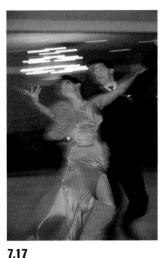

7.17

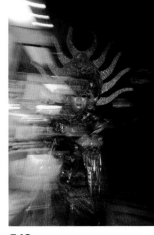

7.18

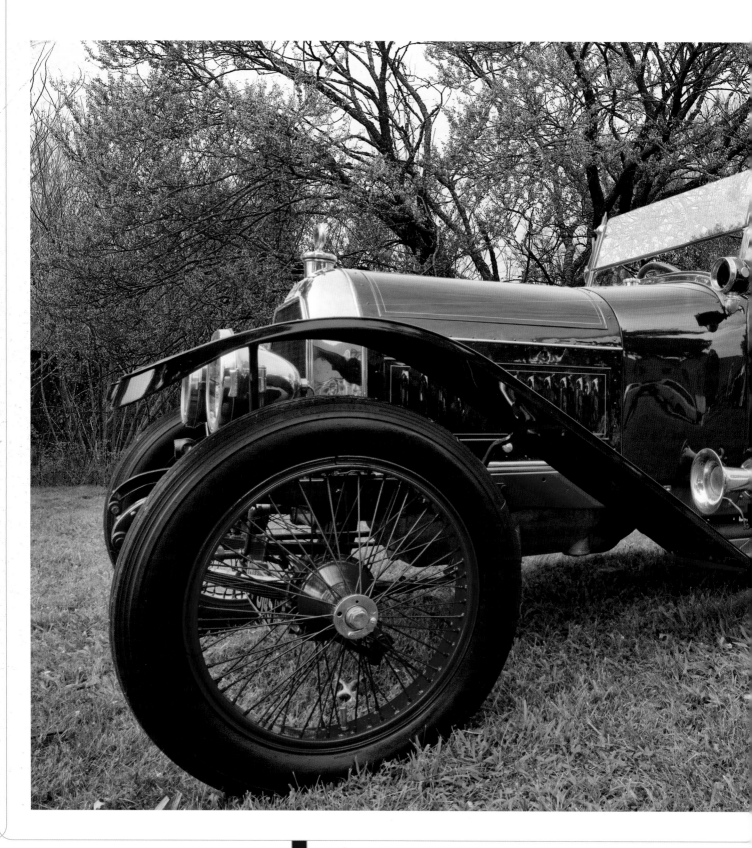

Cameras and lenses are often equated with the human eye. It is obvious that there are similarities—both perceive the world visually and capture images that are processed by a digital sensor or the brain, respectively. In addition, both lenses and our eyes respond to light by varying an aperture that adjusts the amount of light that is allowed in. There are significant differences, however, between a lens and the eye. I feel that it's important to understand these differences because they have a direct bearing on how you photograph your subjects.

THINK AS THE LENS SEES

For example, our eyes approximate a 50mm, or "normal," lens. We don't see the world through a lens that resembles a wide-angle, and we certainly don't have the magnification capability of a telephoto lens. Since it is lenses, and not our eyes, that capture photographs, this means that we must learn to previsualize what a picture will look like based on how a lens perceives a scene or a subject, not how our eyes see it. This is very important and I encourage you to read the previous sentence again. I titled this chapter "Think as the Lens Sees" to underscore this concept. This is exactly what you have to do to consistently take good pictures. You must mentally see the world the way your lenses do in order to immediately know which lens is best for a given situation.

8.2

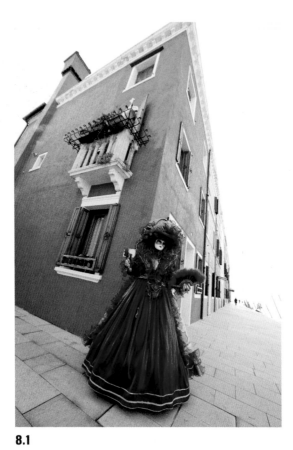

8.1

Stretch Your Perspective

A wide-angle lens interprets a scene with certain characteristics that are not at all like how we perceive the same scene with our eyes. Wide-angles exaggerate perspective and they seem to stretch the lines that make up a composition. In addition, when the lens is placed close to the foreground, the elements close to the camera position seem disproportionately large. For example, in the portrait of a costumed model on Borano Island near Venice, Italy (**8.1**, left), the 14mm lens I used (on a full-frame camera) elongated the sidewalk so it seems like it stretches

8.3

almost to infinity, while the model, who was only about four feet away, seems unnaturally large in the composition compared to the architecture. You can see the same type of distortion indoors in photo **8.2** (opposite, top), where I photographed my wife in costume during one of my photo tours to Venice. Note that the distortion caused by the ultra-wide-angle isn't bad, even though the distortion caused by wide-angles lenses can often be unflattering for human subjects. In this case, though, it's a stylized look that makes a powerful and compelling image.

The dramatic picture of a snarling leopard in Namibia (**8.3**, above) was made powerful by the use of a wide-angle lens that was only about two feet away from the cat. This close proximity exaggerated the perspective and made the leopard seem incredibly menacing. The leopard was behind a fence, but it was still a dangerous situation to get this close. I envisioned this kind of dramatic interpretation by thinking as the lens sees—in other words, I could previsualize what the final result might be. I didn't see this with my eyes, but I knew that a wide-angle lens would give me this kind of look.

8.4

8.5

above

Wide-angle lenses distort reality. Learn to previsualize this so you know what to expect from them, even before you look through the viewfinder.

left

Telephoto lenses do the opposite: They compress perspective. The rhinos in these two photos appear very different, but they are in fact about the same shape and size—they're just photographed using different lenses.

I did the same thing in the unusual picture of a black rhino (**8.4**, opposite, top). Notice how elongated the animal is because I used an extreme wide-angle (a 16mm on a full-frame sensor) and I was physically quite close to this captive rhino. Note also the remarkable depth of field, which is characteristic of wide-angle lenses. Not only is the rhino in focus, but the distant background is, too. Compare this image to **8.5** (opposite, bottom), where I used a telephoto lens (400mm). Here you can see a very different type of image. The depth of field is relatively shallow, the perspective is compressed rather than elongated, and the feeling is completely different.

Another example of wide-angle distortion is the picture of a 1914 Peugeot (**8.6**, below). The front end of the vehicle is distorted. It seems larger than the rear. By placing the camera with a wide-angle lens close to the front of the car, I was able exaggerate its lines and give emphasis to the front end.

If you can divorce yourself from the idea that cameras capture what you see, you will take a quantum leap toward producing great images. When you study any photographic subject, from landscapes to flowers, people, city scenes, pets, etc., first imagine how your subjects will look with a wide-angle lens and then envision them taken with a telephoto. This "imagining," which is really previsualization, is the key to fundamentally understanding the photographic process. Study your wide-angle and telephoto pictures, and once you see what these lenses give you, you'll have a mental picture that can be superimposed, so to speak, over all future photographic situations.

8.6

left
Disproportionately large foregrounds are characteristic of wide-angle lenses. The wider the lens, and the closer you get to the foreground, the more exaggerated this effect becomes.

Chapter Eight

Unify Visual Elements

Telephoto lenses, as you've probably guessed, don't give you the type of images you see with your eyes either. Long lenses compress perspective, giving the appearance of less space between distant objects. For example, all of the flamingos in photo **8.7** (right), photographed in Lake Nakuru, Kenya, seem to be flying at essentially the same plane. However, the birds were at different distances from the camera by at least ten or fifteen feet. The same kind of compression is seen in photo **8.8** (below), of Indian soldiers marching in New Delhi. The men seem very close to the Red Fort in the background, but in reality, they were at least 200 feet away from it.

8.7

Another characteristic of telephoto lenses is their shallow depth of field. Our eyes always give us complete depth of field, where everything in our experience is in focus (assuming you are wearing prescription glasses if needed). If you place an object four or five inches from your face and try to focus on the background with your peripheral vision, then can you see that depth of field becomes an issue. (Or, try holding your finger in front of your eyes and, while focusing on it, notice the background. You'll see that more distant objects appear somewhat out-of-focus). For all practical purposes, though, everything we look at

8.8

8.9

is in focus. With telephoto lenses, however, that's not the case. Foregrounds and backgrounds are often out-of-focus, and this is more pronounced the longer the lens is. The soft background behind the wild dog in image **8.9** (above) is ideal from an artistic standpoint because it forces all of our attention on the subject and nothing in the distance is distracting. However, this is not at all what I saw. My eyes perceived the background as entirely in-focus with complete detail. The same is true of the background behind a Harris hawk in flight (**8.10**, right). This was taken with a 500mm f/4 lens, and notice how undefined the distant foliage is. When I looked at this scene, I could clearly see the individual leaves on the trees behind the bird.

My point is that telephoto lenses capture something other than what we see—a compressed perspective, plus backgrounds that are usually out-of-focus. Therefore, as you assess a subject or a scene, you must think as the lens sees.

Imagine the compressed perspective and the shallow depth of field. See in your mind's eye how the long lens crops out extraneous elements and how it frames just your subject. Our eyes don't do this, but our mind can.

8.10

Translate Your Vision

What I am suggesting here is that you get very good at previsualizing what a subject will look like even before you look at it through one of your lenses. This takes time and practice, but the advantage of doing it is that you can know which of the lenses in your arsenal will give you the best shot. Sometimes both a wide-angle and a telephoto lens should be used to interpret a subject in two different ways. Study the three shots of a Greek ruins (**8.11**, **8.12**, and **8.13**). Two of these are wide-angle images and one of them is a telephoto shot. Can you tell which photo was taken with telephoto? You probably can—it is **8.12**. This is the

kind of visual knowledge you must have as you photograph in the field. Sometimes only one lens is appropriate, and sometimes you can shoot a subject with a variety of lenses as I did here. When time is of the essence, when you may miss a shot if you don't act quickly, it is invaluable to be able to assess a situation very fast and choose the right lens before you start changing lenses.

This visual knowledge is a skill that you acquire over time, and it makes you realize that your eyes are not the only determining factor in capturing beautiful images. Your lenses are

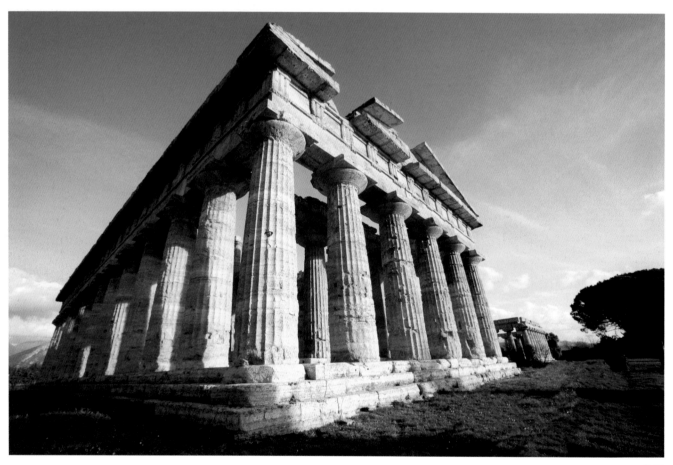

8.11

such a big part of it. Instead of feeling frustrated that you didn't capture what you saw, you'll realize that photography is not about doing that. Photography is about capturing what the lenses are capable of seeing. This is a big deal, and it will have a profound impact on your work. How often have you heard someone say (or perhaps you have said this yourself), "You should have been there—the camera just didn't capture what I saw"? One of the reasons this occurs is that most people are expecting (or hoping) that their camera is simply an extension of their eyes, and that just isn't true.

8.13

8.12

Chapter Eight

In art and photography, absolute rules usually don't apply. People have different tastes and standards, and when I make a statement about what I feel improves the images you take, there will probably be those who disagree. Having said that, let me make a generalization about the exposure of the subject compared to that of the rest of the picture. I feel that the subject should usually be the brightest part of the composition. That is one way we can direct a viewer's attention to the most important part of the photo—the subject. I learned this from the work of famous Renaissance painter, Rembrandt. By studying his renowned painting *The Night Watch*, I realized that the individuals in the painting to whom the artist wanted to give the most attention and prominence were painted much lighter than anything else in the scene.

CONTROL HIGHLIGHTS

In the simple snapshot of my Great Pyrenees, Rexie (**9.1**, below), who was relaxing on a chair in the family room, you can see the same principle at work. I used only the on-camera flash for lighting, so everything in the picture is muted and dark except Rexie, and that's where our attention is riveted. (At the time this picture was taken he was a puppy of 18 weeks and already 55 pounds!)

When there are highlights in a picture that are brighter than the subject, our eyes are diverted toward those bright areas, and that's not how a successful picture is supposed to work. For example, in the photo of the colorful public telephone at the airport in Amsterdam (**9.2**, above), the white placard giving dialing instructions takes attention away from the phone itself. Your eyes move away from the phone toward the white area, and it's somewhat annoying to have that bright element in a picture that is otherwise middle-toned. Compare this original image with example **9.3** (right). I used Photoshop to replace the placard with a background in keeping with the green enclosure, and now there is nothing that diverts our attention from the subject.

9.2

this page
Being aware of elements in a picture that detract from a subject is crucial to taking great pictures. Sometimes, though, there is nothing you can do to make the photo better without using Photoshop. Here, I replaced the distracting white placard in post-processing.

9.3

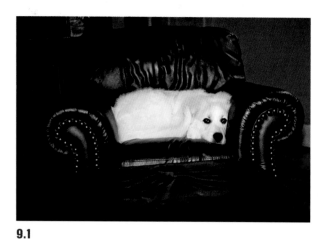

9.1

A white sky is often a distraction to darker subjects for the same reason. When I photographed tulips on an overcast day (**9.4**, below), the soft lighting was beautiful for the flowers (this is the ideal type of light for all floral photography), but because I shot this from ground level looking upward, the white sky was included in the composition. I feel it distracts from the flowers despite how saturated they appear. That white area overpowers even super-saturated color and pulls our eye away from it. I used Photoshop again to illustrate the difference between how a white sky influences a picture versus a sky filled with gray clouds. In photo **9.5** (below) the sky doesn't detract from the flowers the way it did in **9.4**.

9.4

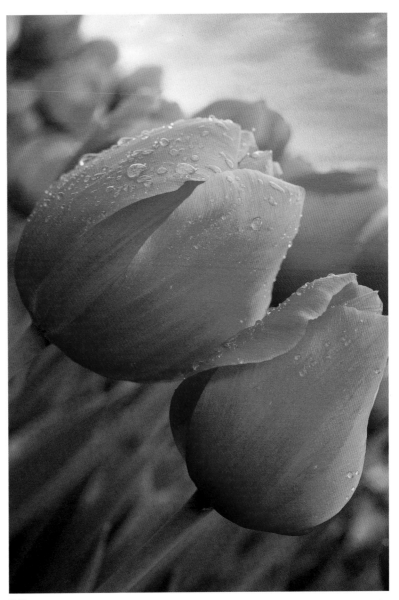

9.5

this page
White skies are often distracting because they pull our eyes away from the subject. Notice that the darker sky helps direct our attention where it's supposed to be—on the tulips.

Many times, a sky will be filled with light gray clouds, and when you expose for the darker landscape or architecture, the sky becomes washed out, losing detail. Such was the case when I photographed Ogrodzieniec Castle in Poland (**9.6**, right). If I exposed for the light gray sky, I'd get detail in the clouds, but the castle and the grass would be unacceptably dark. By exposing for the lower part of the image, I lost all detail in the sky. I could have used the HDR technique (combining multiple exposure of the same image to get a perfect exposure), but I didn't like the existing sky enough to do that. Instead, I knew I could replace the sky entirely in post-processing, and you can see the result in image **9.7** (below). Now the sky adds

9.6

drama and impact to the scene. I keep a large file of skies to add to pictures like this one, because the sky can make or break a picture.

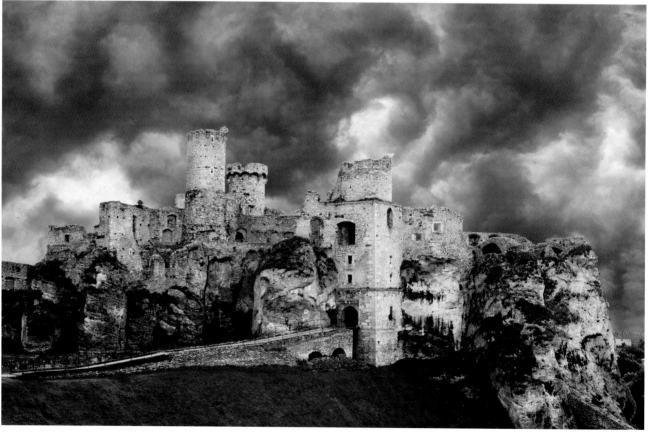

9.7

When you photograph birds, animals, or flowers, and the background consists of branches and leaves of a tree, the bright sky seen intermittently through all that vegetation can be distracting as well. I spotted a two-toed sloth in Costa Rica during the middle of the day, and while the animal was in the deep shade of the underside of the tree, the daylight between the leaves was unattractive and visually detracting. I've circled each area of the background that is problematic in example **9.8** (below, left) to show you what I'm referring to. In the comparison shot (**9.9**, below), I had a better angle and most of the sky was eliminated from the picture. I did use Photoshop to clone out a few white areas that still persisted, and you can see what a big difference it is to not have all those very bright highlights behind the subject.

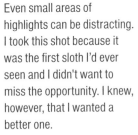

9.8

left
Even small areas of highlights can be distracting. I took this shot because it was the first sloth I'd ever seen and I didn't want to miss the opportunity. I knew, however, that I wanted a better one.

right
I followed the sloth as it moved in the tree, hoping for a better perspective that didn't include so many highlight areas. Patience and persistence paid off, and you can see that this background is complementary and non-distracting without the white highlights.

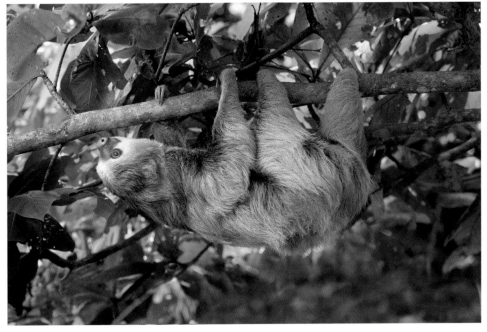

9.9

9.10

In addition to white areas in the background that are distracting, very bright colors can also be visually annoying. They compete for attention with the subject and that's the last thing you want. The out-of-focus red color behind the young boy in Istanbul, Turkey (**9.10**, left) is a good example. This picture has white highlights at the top of the frame, which does hurt the image, but even more offensive is the soft red color. This kind of color highlight is acceptable if it is part of the subject, but as part of the background, it doesn't work.

Another example of offending bright colors in the background is the garden scene behind the brilliant orange tulip in photo **9.11** (right). The highlights at the bottom of the composition are not ideal, and the orange and purple flowers to the side and beneath the subject flower really pull our eyes away from the dominant blossom. In a large garden, you have to be careful not to be enthralled by all the color and forget about good photographic principles. Look how much more effective and artistic the picture is with an out-of-focus green background in photo **9.12** (right). Now, nothing competes with the subject for attention. Obviously, in the real world, backgrounds are not always to our liking. The possible solutions are as follows:

1 shoot something else

2 change your shooting angle and perhaps you can use a different background, or

3 use Photoshop to replace an undesirable background.

If you want to include an entire area of color—in a garden, for example—as in photo **9.13**, that's perfectly fine. In this case, both the foreground and the background are the subject. As such, one doesn't distract from the other. They are both important in contributing to the success of the picture. This will take some practice. You may need to shoot a scene with and without its strong background elements and compare later, in order to get a feel for what works and what doesn't.

9.11

left
Colorful objects in the background can have negative impact on a photograph, even if they are out-of-focus. They can often pull the viewer's eye away from the subject, like in this picture of a tulip.

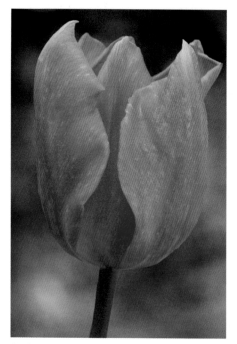

9.12

left
Notice how the soft and diffused light brings out the rich, saturated colors in this garden shot I took in Holland. I couldn't have asked for better lighting for this type of scene.

9.13

Out-of-focus foregrounds should be avoided in most photographic situations. Our eyes always give us complete depth of field, so we never see an out-of-focus foreground as we look into a scene. Cameras, however, don't capture scenes the way our eyes see them.

AVOID OUT-OF-FOCUS FOREGROUNDS

One example of that difference is depth of field, which is controlled by the lens aperture, camera-to-subject distance, and focal length. If you photograph a subject at, say, a focal length of 200mm, an aperture of f/4, and a distance of ten feet, the foreground will likely fall in front of the plane of focus. And, generally speaking, when elements in the immediate foreground of a photograph are soft, they are visually annoying and they detract from the quality of the image.

Whether or not foregrounds are going to be sharply defined is especially important to consider when dealing with subjects close to the camera position, where depth of field is so critical. When the elements in your scene are far away, such as the dune crests in example **10.1** (right), you will be able to have complete depth of field at any lens aperture. However, when foreground elements are within a few inches or a few feet of the camera position, you must use a small aperture to render the foreground (as well as the background) in focus.

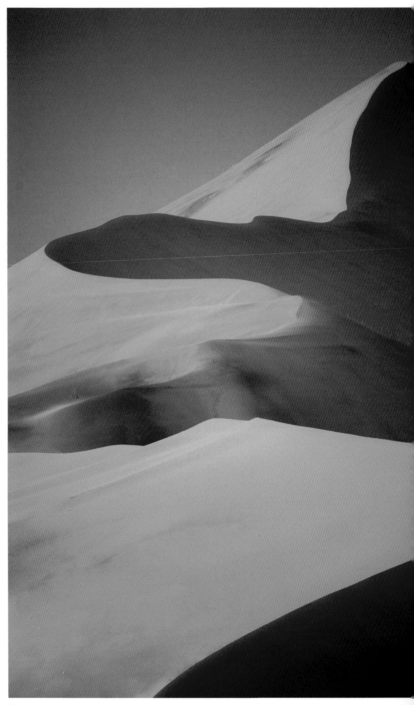

right
Because the dunes were so far away from the camera position, I was able to use a large lens aperture (f/4 on a 500mm lens) and still maintain sharpness for both the foreground and the background.

10.1

Insect photography is technically challenging. As you move in very close to small subjects, depth of field becomes extremely critical. Pay special attention to making your shots as sharp as possible.

10.2

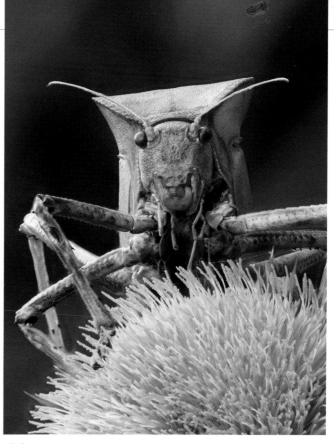

10.3

What's Shutter Speed Got to Do with It?

The only way you can increase depth of field (without changing lenses or the composition) is by closing the lens down to a smaller opening. And that, of course, means a longer shutter speed, which in turn, means using a tripod. I know that isn't good news, but if you want perfect images of non-moving subjects, tripods are essential because they allow you to hold detail throughout an image.

If you are shooting fast-moving subjects, on the other hand, shutter speed is the most important issue; aperture—and therefore depth of field—is a secondary concern. You first have to determine whether you want the subject sharp or blurred and then choose a shutter speed based on that. At this point, your shutter speed will likely limit you to a certain range of apertures, a factor that leaves you with less control over depth of field than you would have if the shutter speed were not important.

When filling the frame with small subjects, depth of field is especially shallow. Macro photography is all about revealing detail, but too often, photographers

shoot insects, flowers, leaves, mushrooms, and other small subjects without a tripod. If you don't use a tripod, it means that you can't use a slow shutter speed. A fast shutter speed forces you to use a large aperture, and consequently the depth of field is sacrificed. Lens apertures like f/4 and f/5.6 aren't small enough to give you the depth of field needed, and foregrounds end up being too soft. A case in point is the katydid I photographed (photo **10.2**, above, left). The thistle flower is very distracting to this shot because all of that detail is lost in the blur. The distant trees are out-of-focus, and that's fine for the background—desirable, actually. The soft flower in front of the insect, though, is visually annoying. Compare this with example **10.3** (above) and you can see the difference. Now, the detail in the flower adds to the artistry of the picture and nothing in the foreground detracts from the overall image.

Getting Away with It

There is one major exception to the rule that out-of-focus foregrounds are to be avoided: Selective focus refers to using shallow depth of field and isolating a subject by focusing on it and throwing the rest of the image significantly out-of-focus. This is a creative technique and it has some great applications. For example, the male lion I photographed in Botswana (photo **10.4**, below) is surrounded by out-of-focus foliage, while the cat itself is tack-sharp. Notice that the foreground vegetation is so out-of-focus that it is almost like a haze of earth-toned color. In my opinion, this is the only time when an out-of-focus foreground is acceptable. It has to be nothing but a blur of non-distracting color, beyond which we see the subject. You can see the same effect in the shot of the flower in **10.5** (right). In order to get this kind of extremely shallow depth of field, I had to use a large lens aperture and, at the same time, fill the frame with a small subject. I used my 70-200mm lens at f/2.8 with two extension tubes for extreme magnification and minimum depth of field. In this way, I could make the foreground so soft that it turned into a haze of color.

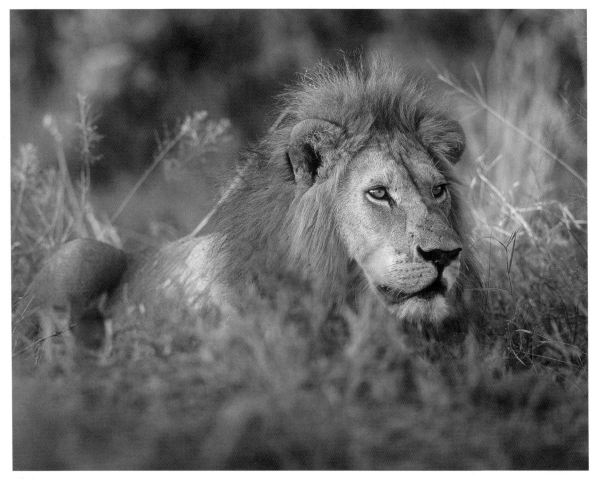

10.4

10.5

left
Out-of-focus foregrounds usually only look good when they are so soft that there's no definition at all.

10.6

If the foreground is out-of-focus but you can still see definition in it, the picture won't be successful. Compare the two images of an Argentine black-and-white tegu, (**10.6** and **10.7**, at right). You can see in the former that the tip of the animal's nose is soft, and this hurts the picture. After I took this shot, I recognized the problem, and fortunately, I still had time to photograph the reptile from a different angle. Photo **10.7** shows his entire head sharp, and even though the background is out-of-focus, the fact that the foreground is sharp—as well as the tegu's eye—means that this is a successful image.

10.7

A great example of a picture I consider a failure is **10.8** (right). The flower is beautiful, but the out-of-focus foreground elements are terrible. In this case, they are out-of-focus and lighter than the subject, both very distracting qualities. It is hard to appreciate the flower itself because the foreground competes for our attention... and gets it.

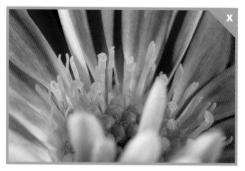

10.8

Sometimes, you simply cannot avoid having distracting foreground elements. Compare the immediate foreground in photos **10.9** and **10.10** (below). In the shot of a mother lioness and her two cubs drinking at a water hole in Namibia, the rocks in the foreground are out-of-focus because I was shooting from a blind with a long telephoto at ground level. The rocks were in the way, and there was nothing I could do at the time to change positions or even raise myself to shoot over the

rocks. I've always liked this picture except for the foreground. As far as I'm concerned, it ruins the photograph. On the other hand, the soft foreground in front of the cheetah in photo **10.10** isn't as prominent, so it doesn't bother me as much as the rocks in front of the lions. In addition, the grass immediately in front of the camera lens that looks completely out-of-focus blocks other grass that was closer to the cheetah and that would otherwise have detracted from the picture.

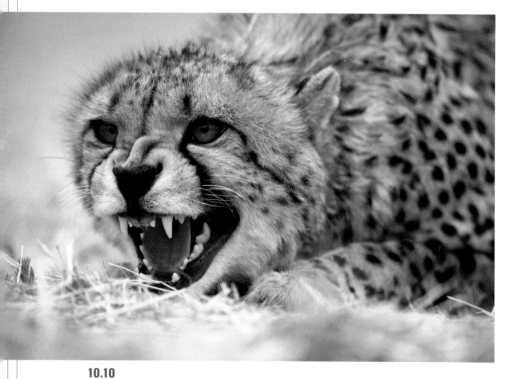

10.10

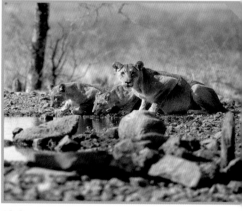

10.9

left
When shooting pets and wildlife, get as low as possible. This makes the pictures more intimate and compelling.

10.12

Working Around It

I needed some help with depth of field in the case of **10.11** (right), because when you use a telephoto lens positioned very close to foreground elements, even f/32 isn't a small enough lens aperture to produce the kind of depth of field you want. You can see that the tree and the grass in the foreground are out-of-focus, and the tree is especially distracting. So, I used Helicon Focus, a relatively new software program that enables you to get complete depth of field at any lens aperture. This is how I made the second shot, **10.12** (above). The sharpest lens aperture on any lens is f/5.6 or f/8, and when I use this technique I usually choose f/8.

The way this works is that you take a series of pictures with the camera on a tripod. You begin focusing at the furthest point in the scene, and in very small increments, you pull the focus back toward the camera position. I typically take 10 or 12 images, focusing closer and closer to the foreground until the last picture is focused on the immediate foreground elements. I shoot in RAW, of course, and when I process each of the images and save them as .tiff or .psd files, I put them in a folder on my hard drive. I then open Helicon Focus and

10.11

browse to find the folder with the pictures. The software will assemble all of those pictures together so that the final composite is completely sharp throughout. You don't have to make everything in the picture sharply focused, however. If you want to leave the background out-of-focus as I did in the picture of the katydid on page 115, you could do that very easily. In that picture, I could have rendered the distant background completely sharp, but for artistic purposes, I preferred it totally abstracted. The software is extremely easy to use and the process takes just a minute. You can download a 30-day demo here: www.heliconsoft. com/heliconfocus.html.

10.13

A technique I use often that allows me to circumvent out-of-focus foregrounds—where I can't use Helicon Focus—is to take two shots of a scene and them put them together later in Photoshop. For example, I photographed a leopard in a tree on one of my photo tours to Africa, but the large branch in front of the snoozing cat was about eight feet closer to the camera. You can see the problem I faced in photo **10.14** (below). When I focused on the leopard, the branch was unacceptably out-of-focus. When I focused on the branch, the cat wasn't sharp, and this certainly didn't work either (**10.15**, bottom).

10.14

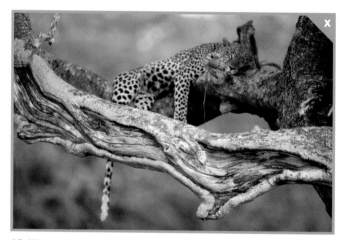

10.15

When out-of-focus foregrounds have colorful components, they are especially distracting. The photo of the spotted eagle owl (**10.13**, above) that I shot in Namibia isn't a great picture because there were too many branches in the way, but the biggest problem is the yellow flowers. They are so bright that, just like a sunny highlight, they take attention away from the bird. This was taken with a 500mm f/4 telephoto plus a 2x teleconverter, giving me 1000mm of magnification. The lens threw the foreground so out-of-focus that it should be acceptable, but because those flowers were lighter than the owl, they hurt the picture. I didn't have any other vantage point from which I could see the subject, so I had to accept a less-than-perfect picture.

The 500mm lens I used to shoot this has shallow depth of field, especially at f/4 or f/5.6, and I couldn't use a smaller lens aperture because I was shooting from a vehicle and I didn't have a firm support that would enable me to use a long exposure time. Without the ability to use a long exposure, I couldn't close the lens down for maximum depth of field. The vehicle was stopped, but there were three other people in it, and people cannot be perfectly still. Taking several shots in order to later use Helicon Focus was not a viable option in this situation, either, because even the slightest movement between shots means that the images cannot be accurately aligned.

Therefore, my only option was to take two pictures, one with the cat in focus and one with the branch in focus, and put them together later. When I got home, I saw that the two images couldn't be laid on top of each other because there was the inevitable slight camera movement between the two pictures. The only way to put these together was to use the pen tool to cut out the sharply defined branch and then paste it into the picture of the sharp leopard. This took some time (I always use a Wacom tablet for precision selection work in Photoshop), but when the composite was complete, I was very pleased (see image **10.16**, below).

10.16

It is difficult to teach photographic composition. Some people innately have an eye to compose great pictures—just like some people can sing on key without any training at all—while others struggle to find a decent picture every time they go out shooting.

With photography, the problem with finding successful compositions is that the world is a compositional mess. In shooting nature, for example, there are rocks, trees, bushes, decaying logs, mountains, dirt, streams, and flowers all over the place, and it's hard to see the compositions that are artistic, graphically pleasing, and beautiful. I can lecture all day long on good composition and show endless examples of great pictures, after which you would go into the field and see completely different landscapes than what I demonstrated. I know this is a problem, and the purpose of this chapter is to address that issue. Instead of discussing art theory, I want to give you a formula that will directly translate into beautiful photographs.

COMPOSE CLASSIC LANDSCAPES

The Formula

Here are the four aspects of what I call the classic landscape technique. In most cases you must use all of them together, and you will find that these techniques will be powerful tools in your arsenal of creativity. If you take them seriously, your photography will take a huge step forward.

1 Use a wide-angle lens—the wider the better.

2 Place the camera position very close to the foreground—within three to six feet.

3 Use a small lens aperture for maximum depth of field.

4 The foreground element(s) should be compelling/beautiful/intriguing in some way, and the background should be similarly worthy of being photographed.

Let me give you two very different examples. Analyze the photograph I took in Keukenhof Gardens near Amsterdam (**11.1**, right) and then study the picture of the boat (**11.2**, opposite) I shot in Ireland. In both images, I used a 16mm wide-angle lens on a full-frame-sensor camera. You can see the exaggeration of perspective characteristic of wide angles, and because I placed the camera so close to the foreground, it appears to be disproportionately large. This is not how the scene looked at all. I created this kind of style in both pictures by using a wide-angle lens about four feet away from the foreground.

In both photos, I used an aperture of f/32. This guaranteed that I had extensive depth of field so that the foreground was as sharp as the background. This meant, of course, that I had to use a tripod. The only way to use a small aperture in

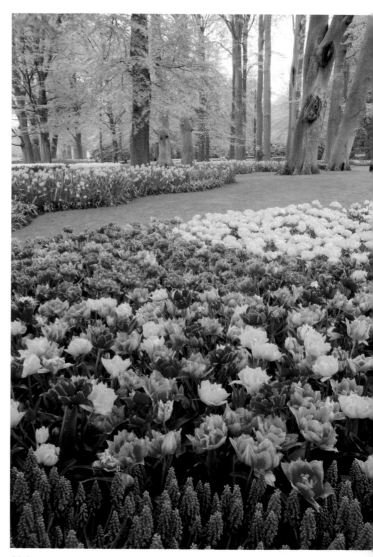

11.1

subdued light and still get a sharp picture is to use a firm support so the inevitable slow shutter speed won't cause any kind of blur.

In both pictures, the foreground elements hold our attention. The artfully planted bed of flowers in **11.1** is ablaze with color and it was beautifully laid out, and the blue boat I photographed on

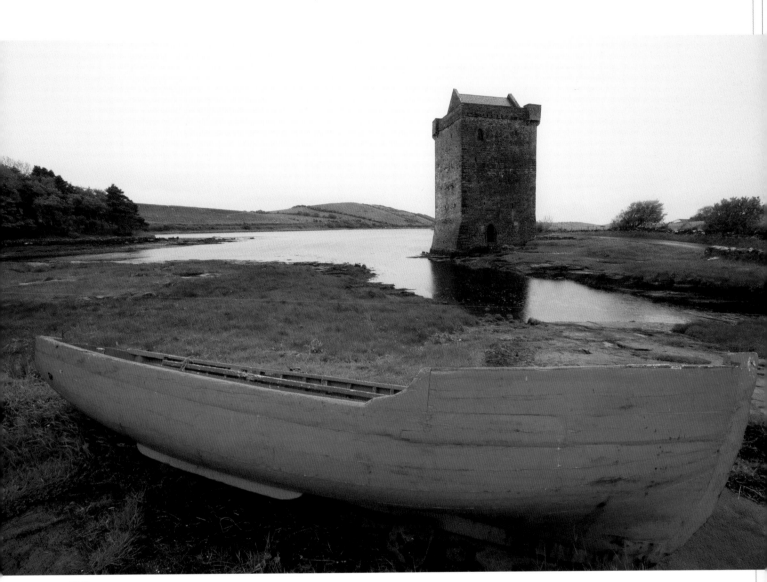

11.2

a rainy day in County Mayo, Ireland has visual impact in the muted environment. The foreground has to be dynamic. The backgrounds in these two pictures are also interesting. The mature stand of trees in the garden look good, and the 16th century castle—while not a stunning work of architecture—is an intriguing historical landmark.

above
Many kinds of elements can be used as dominant foregrounds. A subject that seems mundane can be made very interesting to look at simply by photographing it with a wide-angle lens for a stretched perspective.

opposite
The flowers in the immediate foreground were just three feet from the lens. I focused about seven or eight feet into the frame, and with f/32 at 24mm, that gave me maximum depth of field for this composition with this lens.

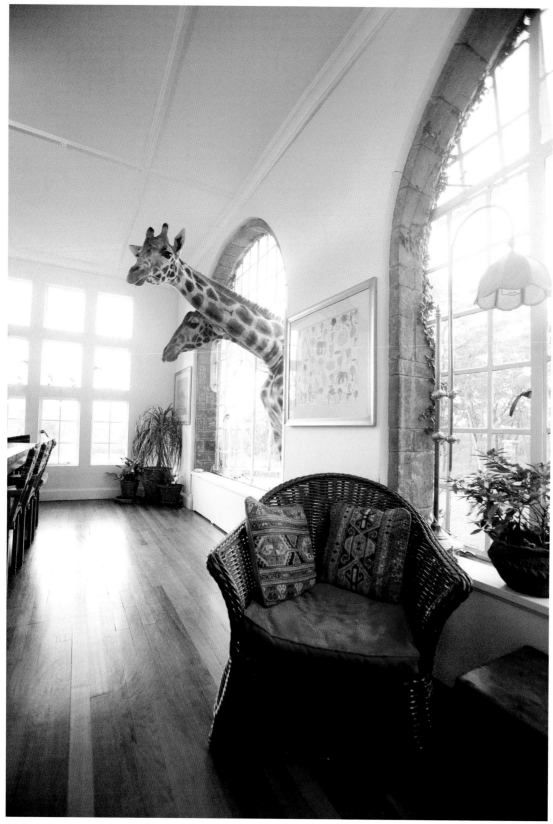

11.3

11.4

I use this same formula over and over to produce not only compositionally pleasing landscapes, but this same technique can be applied to architecture, fashion, portraiture, cemeteries, and sometimes even wildlife. For example, the two giraffes sticking their heads into the Giraffe Manor near Nairobi, Kenya (**11.3**, opposite) were looking to "get lucky," hopeful that a staff member would be handing out corn pellets that day. To get this kind of perspective, I again used my 16-35mm lens at the 16mm setting and placed the camera close to the chair in the foreground. I used this as the dominant foreground element and I stood about six feet away.

Because the light was low, and I couldn't use a very slow shutter speed for fear of blurring the animals, I had to use f/3.5 instead of f/32. However, I got away with it, because wide-angle lenses inherently have a great deal of depth of field. It was the best I could do without setting the ISO too high.

When I photographed the Louvre in Paris at twilight (**11.4**, above), I used the same formula. I placed the lens close to the foreground light, I used a wide-angle lens at f/32, and both the light in the foreground and the classically beautiful museum in the background are strong subjects.

11.5

below
Low, late afternoon sunlight
provided beautiful golden
tones to this wide-angle
shot. Mid-day sunlight
would have made this scene
too contrasty.

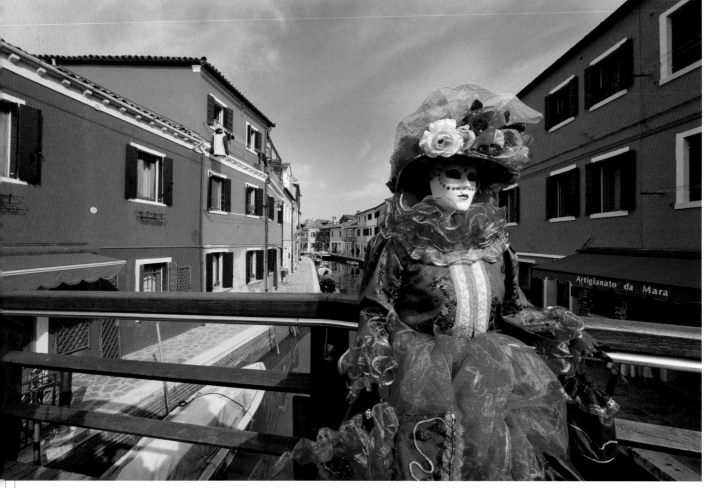

11.6

At Mt. Nemrut in Turkey (**11.5**, left), you can see the same technique used. The colossal head from the Commagene Kingdom, 1st century B.C., was my dominant foreground element and the ruins in the background, plus the dramatic sky, completed the scene.

When you use a model in the foreground, ask him/her to be as still as possible so you can use a small aperture. On Burano Island in Venice, Italy (**11.6**, opposite, bottom), I used the landscape technique effectively because I had a classic background along with a model in an outrageous costume. Note that everything in the image is sharp and that the costumed subject is disproportionately large compared to the background. With a different model, I shot from a low perspective up toward the sky at sunset (**11.7**, below). I used fill flash and I balanced the lighting with the background to retain detail in the clouds. The sky served as the background element. As you can see, I'm simply using the same technique over and over again but with different subject matter.

11.7

Why This Works

I think the reason this formula can help you with composition is that it gives you something to look for when you are shooting in the field. Instead of trying to follow theoretical guidelines for good composition in a location that seems like a visual mess, you have concrete steps to take that will help you improve your work. For example, when I photographed Mabry Mill in Virginia (**11.8**, below), I searched for a foreground element to use close to the camera position and decided on the split rail fence. The fact that I was looking for a foreground helped to focus my attention on the very thing that would help me create a strong composition. In the same way, when I was on a desolate beach on the Skeleton Coast of Namibia (**11.9**, right), there wasn't much to use in the foreground. Sometimes this happens and there's very little you can do about it.

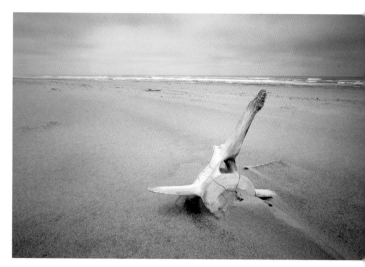

11.9

I finally spotted a whale vertebra, so that's what I used. I placed my camera about five feet from the bone to create the exaggerated perspective. The distant sand, water, and sky didn't make a dramatic background, but the picture does convey a sense of isolation in an inhospitable environment.

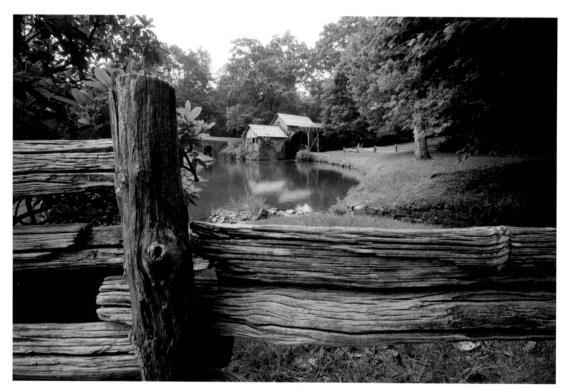

11.8

If you like to set up shots with people, this formula gives you a framework within which you can position a model in relation to the background, and it also suggests how important the foreground element is to the success of the picture. Boring foregrounds make boring photographs. Therefore, you have to consider carefully what you place close to the lens, and

how you shoot it. The picture of my son, Reynold, taken with a 15mm fisheye (**11.10**, below), is a good example. I photographed him wrapped in an America flag as the dominant element on our back deck. I conceived of this beforehand, knowing that the extreme wide angle would make the foreground very prominent and cause that interesting curvature of the deck's straight lines.

11.10

Similarly, when I photographed a dancer in the Hindu ruins of Prambanan in Indonesia (**11.11**, below), I placed her close to the stonework, and both she and the 1000-year-old stonework acted as strong foreground elements.

Where to Focus

You won't always have a clear foreground subject, but that doesn't mean you should refrain from taking pictures. Landscape photos without specific foreground subjects can still be quite stunning. But, with the camera so close to the foreground and with the background sometimes hundreds of feet

away (or more), a question comes up regarding focus: Where should you focus to maximize depth of field? Some instructors may go into the concept of hyperfocal distance to answer this, but I feel this adds a layer of complexity to the issue that isn't necessary. There is an easier way that I have found works well.

Whatever lens you are using, determine the focal length. If you are shooting with an 18-200mm telephoto, for example, and you are using it at its widest focal length, which is 18mm, divide this by three. That gives you the number of feet from

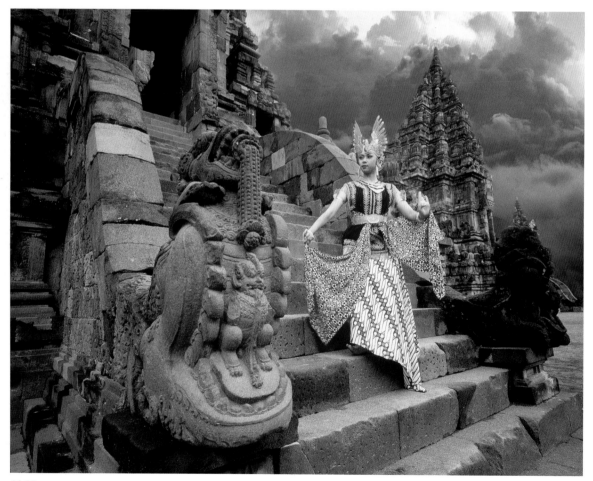

11.11

the lens where the point of focus should be. In this example, you'd focus about six feet from the lens. That means that when you are focused to this distance and your lens aperture is as small as possible, you will have the most depth of field possible for that particular composition, focal length, and aperture. I took the cemetery shot (**11.12**, below) with a 14mm lens on a full frame sensor, so I focused to slightly less than five feet. This doesn't have to be exact, so you can use your best estimate of distance to come up with the correct spot. In the cemetery picture, I focused on the farthest edge of the large headstone in the foreground.

If you have a less-than-full-frame sensor, there is a magnification factor to consider. For example, if you have the Nikon 12-24mm wide angle, the widest setting is 12mm. When you multiple this number by the 1.5 magnification factor, however, the effective focal length is 18mm (i.e., looks like 18mm on a full-frame camera). Therefore, you would use the 18mm number to divide by three and arrive at the focusing point.

below
When shooting toward the sun, be careful about lens flare. Here, I partially hid the sun behind the first headstone to prevent flare from detracting from or obscuring the image.

11.12

　Chapter Eleven

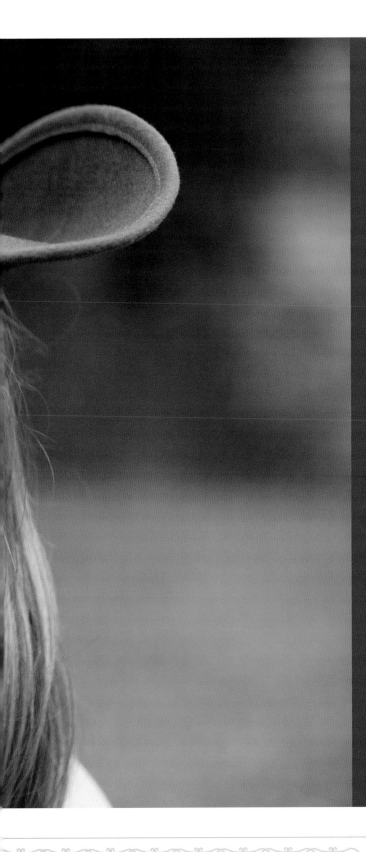

t is easy to underestimate the importance of backgrounds. The fact is that they are virtually as important as subjects in making a picture work. If they are messy and there is a lot going on, they tug at our eyes and pull our attention away from the subject. Just as you carefully consider your subjects, you need to carefully consider the background as you are taking every picture. For example, is it too light? Too messy? Too attention-grabbing? Does it have distracting lines or colors? Is it too sharp or not sharp enough? The background should either complement the subject or it should be an integral part of it.

BEWARE THE BACKGROUND

Avoiding Distractions

Every time you take a picture, it takes just a moment to run your eyes around the viewfinder to look for elements in the background that detract from the shot. A background element is considered distracting when it diverts your eyes and your attention from the subject. For example, the background behind the horse in **12.1** (below) is extremely distracting, not to mention unattractive. The telephone pole, the wire, and the fencing are all pronounced graphic lines that pull our focus away from the animal. Any time you have boldly defined horizontal, vertical, or diagonal lines behind your subject, they are usually distracting. If you stop and think about it, when you see prominent lines behind a subject and those lines are not part of the subject itself, they compete for your attention, don't they?

Another striking example of background lines that take away from the picture can be seen in **12.2** (below). Here, there are repetitive vertical and diagonal lines that are so bold they make it hard to stay focused on the costumed model. This picture is destined for the trashcan.

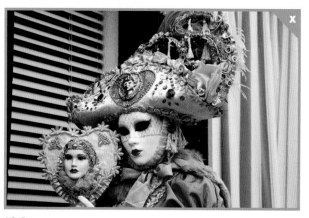

12.2

this page

It is easy to get so excited by a subject that you forget about elements in the background that are unattractive and, in some cases, downright ugly. Backgrounds can make or break a picture. Strong graphic lines that are behind a subject are usually something to avoid because of the way they command our attention.

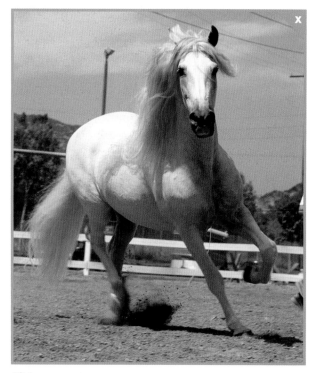

12.1

How Can You Fix It?

Subtly distracting lines degraded a photo of an iguana in Costa Rica (**12.3**, right). The man-made structure above the reptile was a problem, and so were the small twigs in the lower right-hand corner. Those lines cause us to look away from the iguana, and that's not how a successful picture is supposed to work. Using Photoshop, I replaced the original background with a shot of out-of-focus foliage, and you can see the remarkable difference, how the picture is significantly improved in **12.4** (below).

12.3

12.4

Even subtler—but distracting nonetheless—is the light, out-of-focus vertical line of a small branch behind the Damara hornbill (**12.5**, below) I photographed in Namibia. Just because background elements are out-of-focus doesn't mean they are no longer a problem. If they are defined at all and/or if they are light or dark in comparison to the rest of the picture, they will stick out too much and compete for attention with the subject. You can see how this picture was improved in **12.6** (below) after I cloned the offending line out.

12.5

this page
Sometimes subtle changes in the background can make a huge difference in whether or not a picture is successful. After I removed the light, out-of-focus branch, I think this picture is significantly improved.

12.6

When traveling, we photographers usually can't control the background and must accept what we see in the field. Although we can often change a camera angle or use a different lens in an effort to eliminate unwanted elements behind the subject, too often, our only solution is to use Photoshop to replace a messy background. That's what I did with the picture of a leopard climbing down a tree in Kenya (**12.7**, below). I waited for four hours for the sleeping cat to wake up and do something, and I was finally rewarded around 11am. However, the background is about as bad as it gets. It's ugly, distracting, and the lighting didn't help at all. So, using out-of-focus foliage I shot elsewhere, the picture went from being useless to successful (and marketable) simply by changing the terrible mass of branches behind the cat (**12.8**, below).

12.7

right
Too many times, there is nothing you can do to avoid messy and distracting backgrounds other than use Photoshop. This was the first leopard I'd seen on my first African safari, and I waited for four hours for it to wake from its nap and climb down the tree. I sure wasn't going to let an ugly background stop me from getting a good picture.

12.8

The portrait of a horse I took in southern France (**12.9**, right) is another example of a background that I could not control despite my best efforts. I like everything about the shot except the portion of another horse seen in the background. After I took this shot, I changed my shooting perspective to eliminate the problem, but I was not able to capture such a stately pose again. So, I again used Photoshop to clone out the out-of-focus horse (**12.10**, below), and now the picture works nicely.

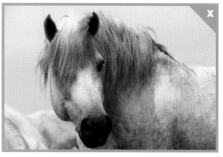

12.9

12.10

Flower photography can be challenging, partly because backgrounds are often very busy. This is especially true with varieties that grow close to the ground or in tight clumps. One easy solution to this problem is to set up a piece of black velvet fabric behind the flowers you want to photograph. Black is a stunning backdrop for flowers, and it immediately eliminates distracting elements behind the subject. In other instances, you may be able to control the background with light. By using natural or artificial light on the foreground and allowing the background to be underexposed, you can eliminate many or all of the distracting elements. For example, the orchids I photographed in a greenhouse (**12.11**, below) were beautiful, but the natural-looking environment behind them was photographically undesirable. The background was too close to the blossoms in this case to use black velvet or creative lighting. In the shot of another orchid plant (**12.12**, right) in the same greenhouse, however, the background was in deep shade. By exposing correctly for the flowers, I was able to isolate them from more distant plants that were, conveniently, several stops darker.

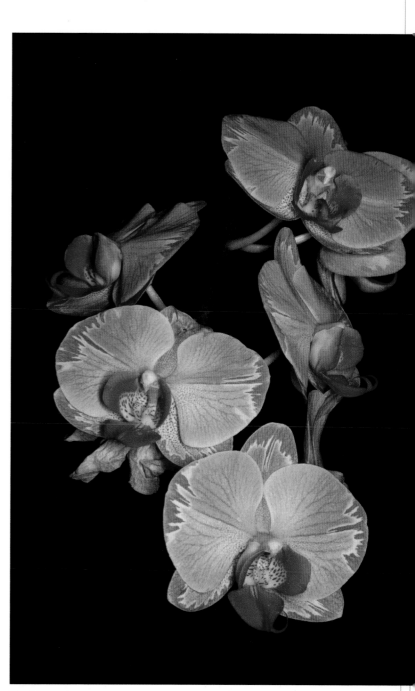

12.12

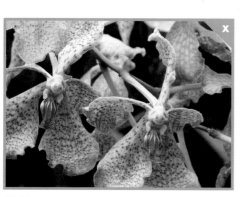

12.11

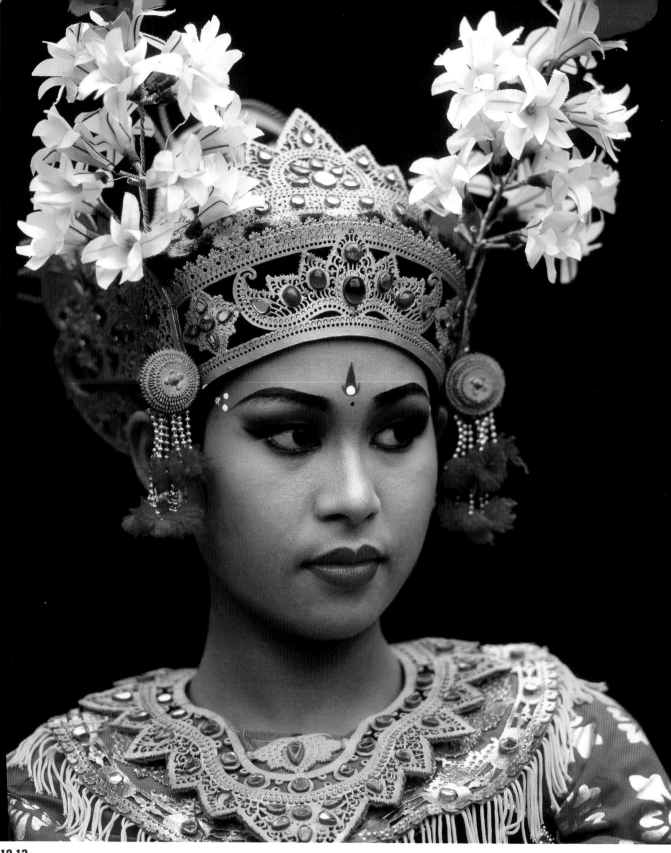

12.13

Ideal Backgrounds

When you photograph people, backgrounds are just as important, if not more so. There are an endless number of things you can use behind a person, but they all come down to three basic possibilities:

1 You can try a solid color such as black or white, as I did behind the Balinese dancer in **12.13** (opposite) and the young Navajo boy in **12.14** (below, left). I had an assistant hold a large piece of black velvet a few feet behind the dancer while she posed for me in the shade of a large tree, and I photographed the boy against a very bright sky.

2 Out-of-focus foliage looks very good behind anyone photographed outdoors. I used this technique in photographing my neighbor's daughter, Grayci (**12.15**, below). I used my 200mm telephoto to throw the background trees out-of-focus.

12.14

12.15

above

The young Navajo boy stood directly in front of the sun so the backlighting would make the feathers come alive.

opposite

When in doubt, black is almost always a complementary background. I prefer to use black velvet because it absorbs light very well and always turns out pretty true to color, while many other black fabrics end up looking dark gray.

above

Out-of-focus backgrounds are achieved not only by using a telephoto lens. In addition, the lens aperture must be large and the subject must be far enough from the background.

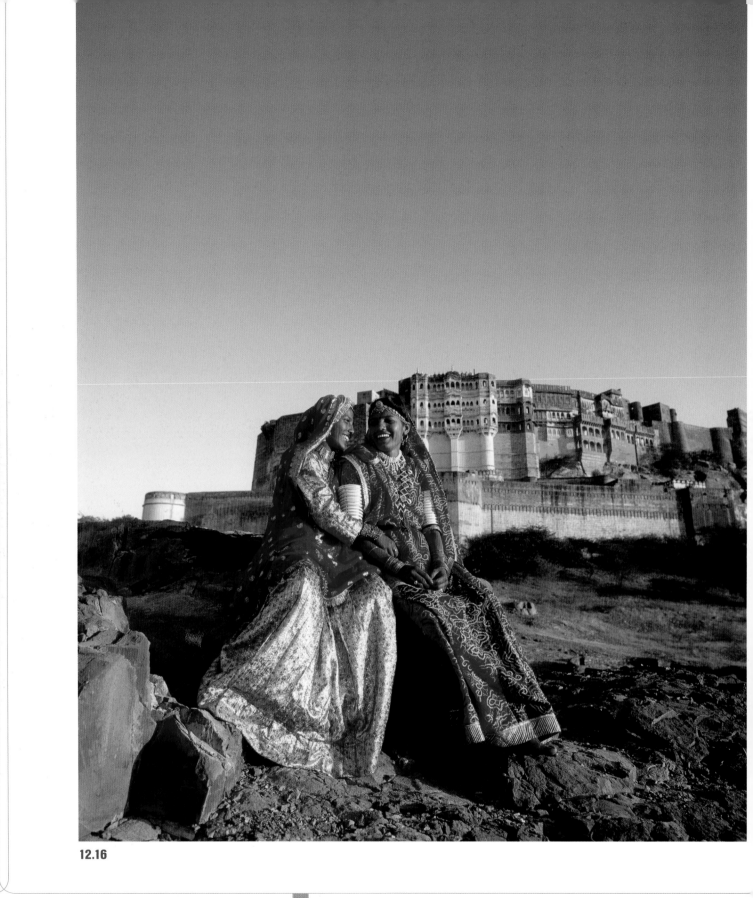

12.16

3 You can make the background part of the picture in an environmental portrait as I did in the shot of the Indian dancers (**12.16**, opposite) in Jodhpur, India and in the picture of my son waiting for the school bus in the rain (**12.17**, below). The street, the fences, and the rainy environment are all part of the background, but they are actually of equal importance in making this picture work.

12.17

above
Inclement weather affords excellent picture opportunities. The main thing you have to watch for is rain drops on the front glass element of the lens. I always carry a microfiber cloth with me just in case.

Taking pictures creatively means being flexible in how you view a subject or a scene. Shooting something straight on is fine—I do it all the time—but you'll also need to find other points of view. I often walk around a scene if possible, looking for other angles and compositions, and if I can't easily do that, I try to previsualize what other perspectives will enable me to capture before I expend the energy to get there.

SEEK UNIQUE PERSPECTIVES

Serendipity at Work

Sometimes unique perspectives present themselves without any effort at all, and all you have to do is recognize the remarkable opportunity. The cheetah I photographed (**13.1**, right) in the Maasai Mara Game Reserve in Kenya is an example. I was sitting in the middle seat of the vehicle when a family of cheetahs climbed up onto the roof of the vehicle. Some of the cheetahs like to use vehicles in place of termite mounds as elevated vantage points to look for prey. To take this shot, I put a wide-angle lens on my camera and shot upward for a very unique angle on an animal in the wild. This was truly an incredible moment.

A similar thing happened in Switzerland. I was doing macro photography of flowers in the Swiss Alps when a cow approached me (**13.2**, right) for a close encounter. Cows are very curious, so I switched to my 16mm lens and lay on my back. The cow came so close that its head was within two feet of my camera! The upward angle provided a very unique shot, and the fact that I used the wide-angle made the animal seem especially large and imposing—and a little silly.

this page
A low perspective where you are very close to your subject only works with a wide-angle lens, and the wider the better. Both the cheetah and the cow were taken with a 16mm lens on a full-frame camera.

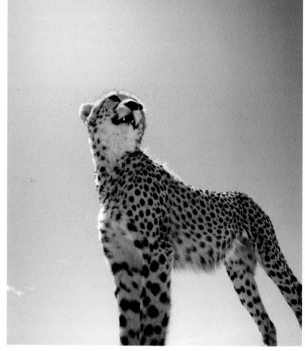

13.1

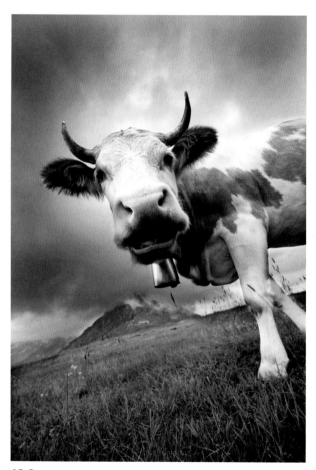

13.2

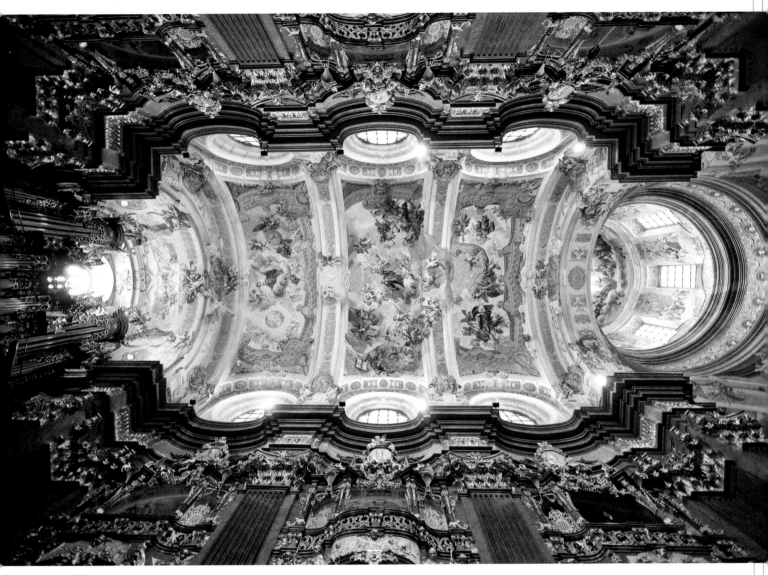

13.3

Be Visually Aware

One of my favorite things to shoot in Europe is the cathedral ceilings. Standing on the ground floor and shooting straight up offers striking graphic designs of the brilliant artistry that, in many cases, took decades to create. One such ceiling that took my breath away is the cathedral in the monastery of Melk, Austria (**13.3**, above). The color, the form, and the detail make amazing pictures from any point of view, but to underscore the symmetry, I like to position myself right in the center. Using a wide-angle lens, especially an ultra-wide angle such as a 14mm or 16mm on a camera with a full-frame sensor, produces the most dramatic results. Another astonishing

cathedral is in Krakow, Poland (**13.4**, below). The blue color is unusual, and again, the ultra-wide lens (14mm) gave me a unique perspective. In many cathedrals, tripods are not allowed, so in the dim light, the only option is to use the widest lens aperture available and use a high ISO. I feel confident when using a wide-angle lens that $\frac{1}{60}$ second will produce sharp pictures. So, my strategy is to raise the ISO until my shutter speed reaches $\frac{1}{60}$. With the newer digital cameras, high ISO settings like 1250 and 1600 produce minimal digital noise that is quite acceptable.

Using the same upward angle technique, I photographed a tribe of Huli dancers in Papua New Guinea (**13.5**, opposite, top). I lay on the ground and asked them to encircle me and bend down, and I used fill flash and a wide-angle lens.

This idea can be used in many situations, such as with the spinning dancer I photographed during carnival in Venice (**13.6**, opposite, bottom left). I used a 14mm wide-angle for the dramatic perspective, and my fill flash combined with a $\frac{1}{6}$-second shutter speed to create an artistic interpretation of the model's movement.

Angling the camera has come into vogue in the last ten years or so, and when it is used judiciously it can be effective. I don't use this kind of perspective often, but sometimes it looks a lot more exciting than a straight shot. When I was changing planes at O'Hare International Airport in Chicago, I photographed a passageway that looked like it was straight out of *Star Wars* (**13.7**, far right). I angled the camera and I think that added to the wild neon design in the passageway.

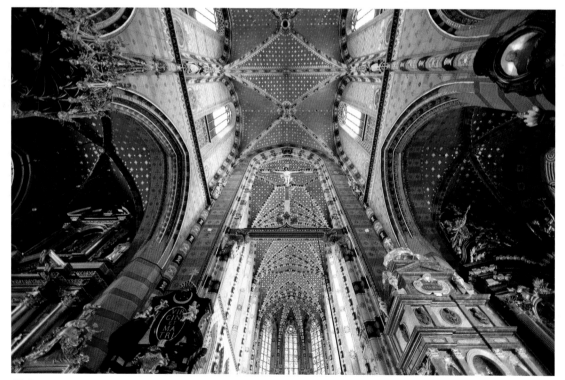

13.4

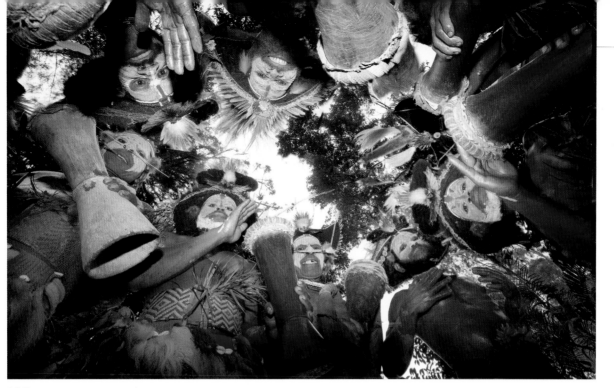

13.5

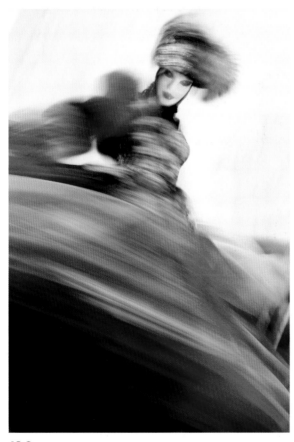

13.6

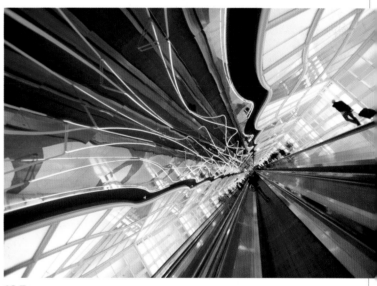

13.7

left and top

If you shoot a person outdoors from a low point of view and they lower their head to face the lens, their face will be in deep shadow. Be aware of the need to add some additional light from fill flash to add some life to your subject's features.

13.8

13.9

above
When I shoot an interior without flash, I use tungsten white balance, not auto white balance. This gives more accurate color.

Whenever I see striking architecture, my tendency is to look up for the possibility of a great photo opportunity. At a hotel in Barcelona, the lobby had an incredible 20-story display of colorful spheres (**13.8**, above), and I was able to get some great shots of it from the main floor looking up, and then also from the 20th story looking down. Shooting downward from an elevated point of view can really get you some great results. In Europe, I climb every clock tower and cathedral bell tower I can to look down on the medieval architecture below. Some skyscrapers have observation decks, and I always take advantage of those as well, and when I am hiking on trails in the mountains, shooting straight down a sheer cliff can produce some great images.

13.10

Think Beyond the Obvious

The graphic shot of a portion of the town square in Bruges, Belgium (**13.9**, left) is a composition that is impossible to capture from anywhere except the top of a nearby structure or a helicopter. In this case, I took the picture from a 13th century clock tower near the square through a narrow stone window. In the Vatican, I climbed to the top of the dome in St. Peters Basilica to capture this classic picture of Rome (**13.10**, above). Note how the symmetry of the columns in front of the cathedral can be appreciated from this height. In Chicago, I photographed the city in the evening (**13.11**, right) from the 94th floor of the John Hancock building. This is just like shooting from an airplane, minus the movement and vibration!

13.11

If I see hills surrounding a village or a city, I know that there will be wonderful vantage points to shoot from. At twilight, I took advantage of this to photograph the beautiful Austrian village of Maria Alm (**13.12**, below). The elevated perspective allows us to have a commanding view that is denied to people who don't take the time to explore nearby trails. It takes time and effort to find the best viewpoints, but it's worth the expenditure of energy, not only for great pictures you can take, but also for the wonderful experience of discovery. I photographed Telluride, Colorado in the wintertime (**13.13**, right) doing the same thing—hiking the local trails until I found a classic-looking view of the city.

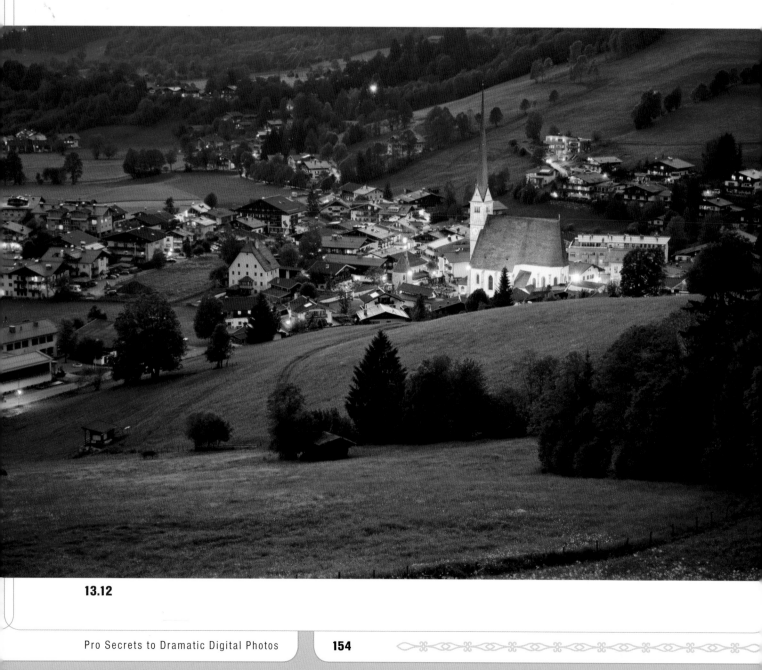

13.12

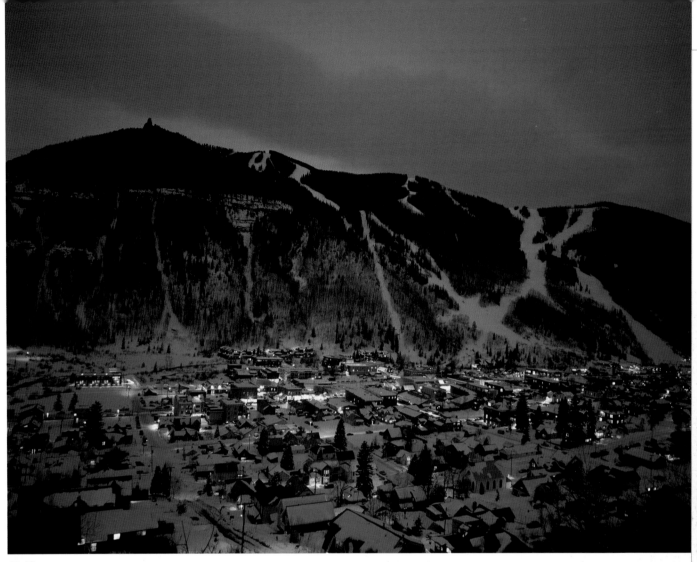

13.13

Photography from an airplane offers one of the most exciting and dramatic points of view. Landscapes and cityscapes look completely different, and the graphic designs you can capture are amazing. Usually, sunrise and sunset are the best times to do this because the lighting is beautiful and the texture on the land is very pronounced, thanks to the long shadows. Of course, there are some quality issues to overcome: You have to use very fast shutter speeds to avoid the effect of the vibration of the plane, and shooting through non-optical quality plastic windows will not give you sharp pictures. I've photographed through the windows of a commercial jet at 35,000 feet, and this is obviously a situation where we have no choice but to shoot through the plastic windows. In this situation, you will get the sharpest images by making the lens axis as perpendicular to the plastic as possible. As soon as you angle the lens so that the axis is oblique to the plastic, the image quality is degraded. If you're able to hire a small plane, that's great, because you can ask the charter company to take the door off so you have an unobstructed view.

One of the best subjects to shoot from the air is sand dunes. You can get myriad abstractions that are simply works of art. For example, **13.14** (bottom left), taken in Namibia, was shot with a 70-200mm telephoto where I zoomed in tightly on the graphic design of the light and shadow on the sand. If you include the horizon, as in **13.15** (bottom right), the landscapes can look like they were taken on another planet. To assure that my shutter speeds were fast to overcome the vibration of the plane, I used aperture priority on f/5.6. This was two f/stops down from wide open and it forced the shutter to be fast. When elements in your composition are relatively far away, depth of field is not an issue the way it is with closer subjects, so I was able to get away with using that large an aperture.

Fixed-wing aircraft such as the high-wing 6-seater I used for the sand dune shots work well because you can cover a lot of distance in the hour or two you are in the air. They can't fly below 500 feet,

13.14

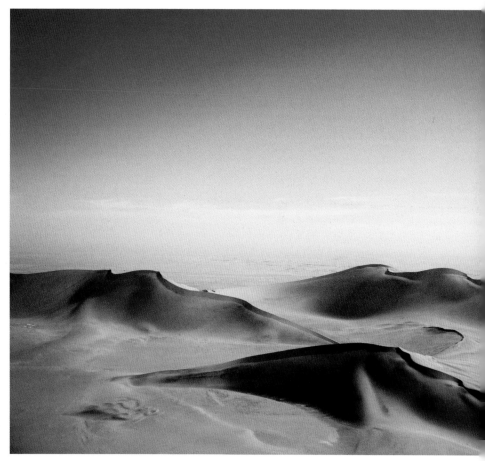

13.15

however, and over cities, the altitude required is usually 1000 feet. If you want to go lower and have maximum flexibility, a helicopter is the answer. It's much more expensive, though. I shot from a helicopter in Rio de Janeiro (**13.16**, right) to get the elevated vantage point on the statue of Christ, and this would have been impossible from a fixed-wing plane. I also shot from a helicopter over the stunning Na Pali Coast on Kauai (**13.17**, below) in Hawaii. This netted me the best shots from the whole trip!

13.16

13.17

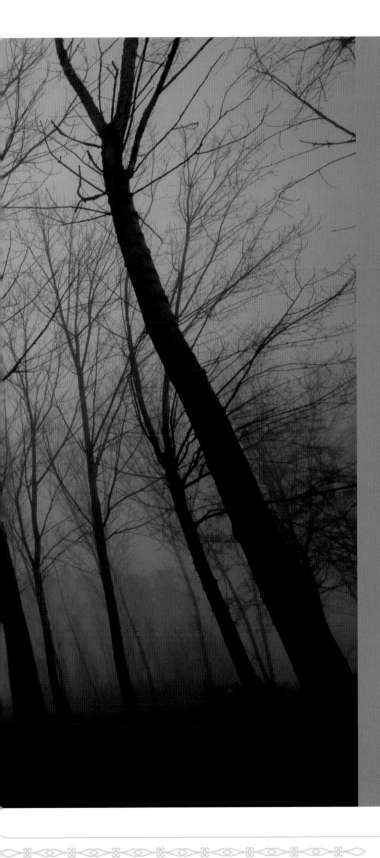

U nlike photographs that scream with color, capture action, and/or portray the world around us with clarity and contrast, moody images seem to have a different purpose. They want us to slow down and feel things—love, sadness, longing, peacefulness, inner tranquility.

CONVEY A MOOD

14.2

What Qualifies as Moody?

There is something very special about moody pictures. They evoke emotional responses from us, and there is a beautiful and magical quality about them. Pictures with mood are often low in contrast, somewhat dark, and sometimes monochromatic. There are many types of circumstances that create moody pictures: candlelight, fog, deep overcast, certain lighting situations at night, a snowstorm.

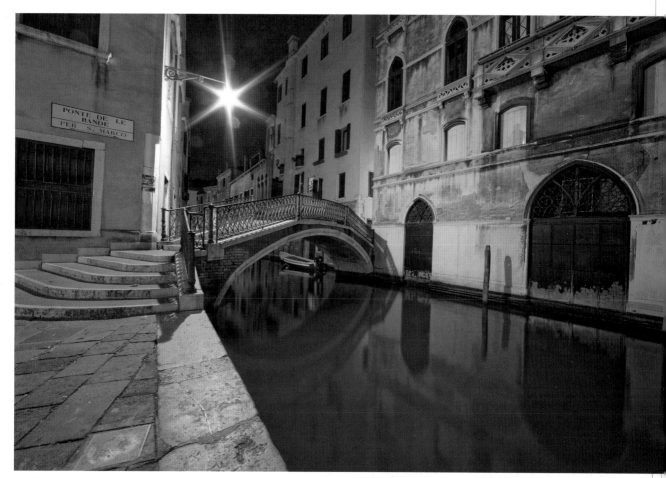

14.3

this spread
Low light conditions like this night shot in Venice, Italy create a beautiful mood. I strongly encourage you to get out at night and shoot. You will be amazed at how the urban landscapes you are used to seeing in the day will photograph so differently after dark.

The photographs of the forest enshrouded in fog (**14.1**, on the previous pages) and the snowstorm in St. Louis (**14.2**, opposite), although they are very different from one another, both have a moody quality about them. The late-night shot in Venice, Italy (**14.3**, above) is also very moody. All three of these shots have different lighting and different color, but what they have in common is mood.

One of my favorite times to take pictures in nature is when a thick fog descends on the land. This creates the most amazing mood of all. In the subdivision where I live in Tennessee, I often see fog in the early morning and I race outside and shoot until it's gone. Before the sun rises, the colors are almost entirely monochromatic, as in **14.4** (below). And with an eastern glow showing through the fog, the mixture of colors is stunning, as you can see in **14.5** (right). The Cinque Terre coastline in Italy was enshrouded in fog when I was there, and I was able to capture the same kind of ethereal, dream-like quality (**14.6**, far right).

14.5

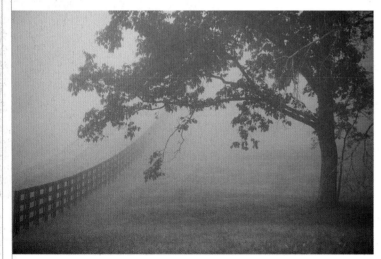

14.4

this page
The combination of a sunrise and a foggy environment can't be beat for mood, beauty, and drama. Early morning fog or low-lying clouds are short lived. Minutes after sunrise, the suspended microscopic water particles are vaporized by the sun and they vanish without a trace.

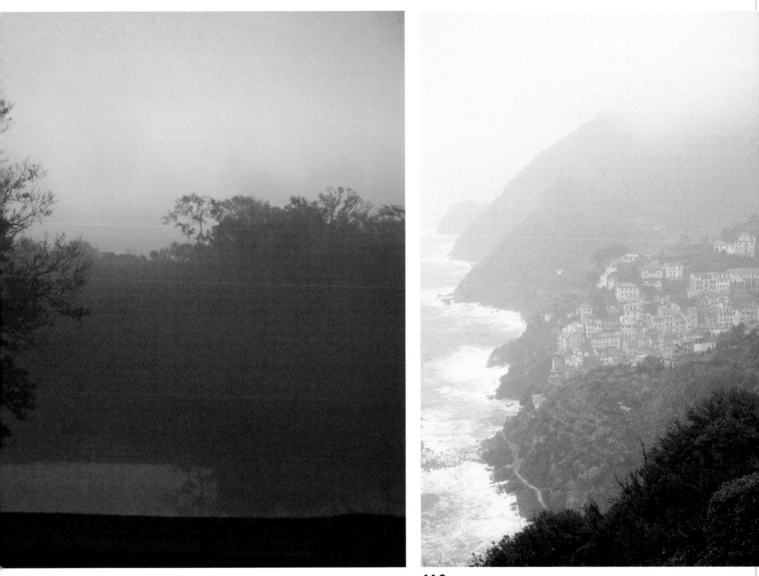

14.6

above
Don't let fog adversely affect your
meter reading. Check the LCD
on the back of your camera to
verify your exposures. If they are
too dark, and they may be when
shooting fog, use the exposure
compensation feature to lighten
the pictures in $1/3$-stop increments.

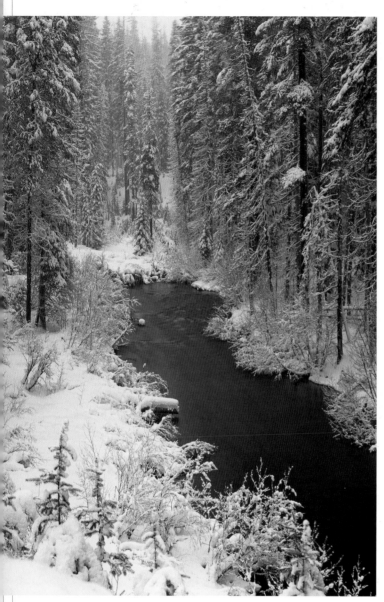

14.8

above

When it is impossible to get sharp pictures in dark environments because the subjects are moving or a tripod isn't feasible (or isn't permitted), the only option is to shoot for "creative blur."

left

Shooting at dawn or twilight creates a bluish cast. Many photographers use post-processing or in-camera white balance to rid images of this color, but in this instance, I liked the effect.

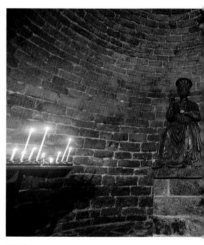

14.9

14.7

Low-light situations create moody atmospheres too. For example, I photographed a section of the Rogue River in Oregon (**14.7**, above) in deep twilight only minutes before complete darkness. This is a 20-second exposure, and the high Kelvin temperature of the evening light resulted in a monochromatic blue landscape that has special beauty about it. The scene did not look bluish to my eyes, but this is the way twilight is seen by photographic media. At the opposite end of the spectrum, I used the available tungsten lights in a pub in Ireland (**14.8**, top, middle) to capture the warm mood of indoors. Because the light was so low, and a tripod was impractical in the crowded room, I opted to blur the scene by changing focal lengths on the zoom lens during the exposure, creating those abstracted streaks of light.

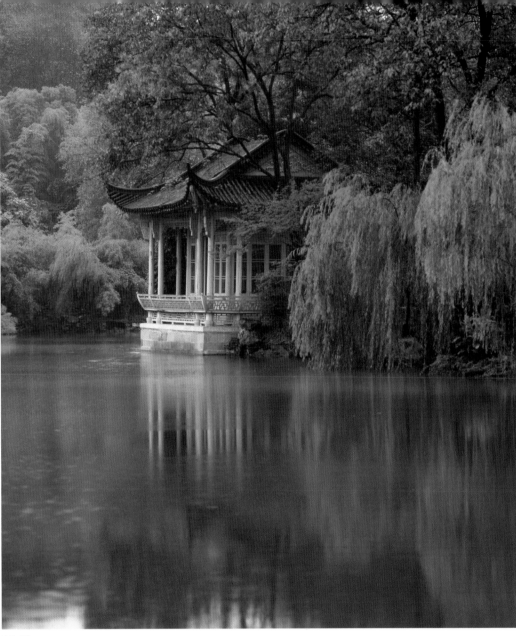

14.10

Overcoming Challenges

Shooting in moody situations can be challenging with respect to balancing the crucial factors that come into play with each picture you take: shutter speed, lens aperture, and ISO. Most of the time, we want sharp pictures, and that necessitates shutter speeds that are fast enough to freeze movement, either the subject's movement or the camera's. The faster the shutter, the less light you have available.

If the light level is low, such as the candle-lit interior of a castle in Italy (**14.9**, middle) or the deep overcast on a Chinese pavilion during a rain shower (**14.10**, above), there are three choices:

1 you can raise the ISO, and/or

2 you can use a larger lens aperture, and/or

3 you can slow the shutter down.

Raising the ISO isn't a great option because of the increase in digital noise and the accompanying degradation of quality. I raise the ISO past 400 only when I have no other choice. Slowing the shutter down is fine if your subject isn't moving, or if you don't mind capturing an artistic blur. And, opening the lens aperture is fine if depth of field isn't an issue.

The strategy I use in integrating these considerations is this: I use a tripod. That solves most of the problems. A tripod enables you to use a low ISO so you can get the best quality out of your digital images, and small lens apertures can be used for maximum depth of field because, if nothing is moving in the scene, it doesn't matter how long the shutter speed is.

If a tripod is not possible, such as in the Irish pub, then presuming you want sharp pictures and the aperture is already wide open, then you must raise the ISO until the shutter speed is fast enough to prevent blur. In my shot of the pub, I wanted to create an impression of the bar rather than taking a documentary picture. This is why I blurred the image. In the shot of gondolas in Venice at dawn (**14.11**, below), I used a tripod but the movement of the boats on the water caused them to blur while the distant architecture remained sharp. Low-light situations can be approached with creative solutions like this, and often you'll be surprised at how intriguing the images are. I used dawn light again in downtown Chicago when I photographed architecture from the underside of a unique sculpture called *The Bean* (**14.12**, right).

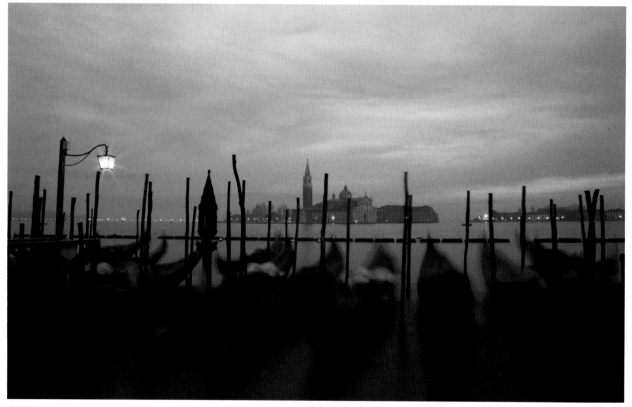

14.11

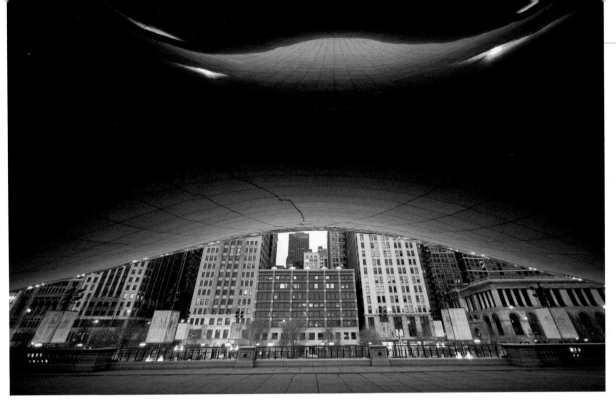

14.12

The moody tones of color and the subdued lighting is characteristic of this time of morning. I like to catch the lights before they are turned off because they add a nice touch to any kind of urban landscape.

Exposure is a concern when shooting in low-light conditions, and this is especially true when a scene is thick with fog, as in **14.13** (right). The tiny airborne particles reflect light almost like snow does, and when the meter interprets the composition as middle gray (all meters are programmed to do this), it will underexpose the shot, which causes white snow or very light fog to look gray. Remember to check the LCD monitor on the back of your camera to see if your images are too dark. If so, tweak the exposure using the exposure compensation feature. Virtually every digital camera has this feature, and it is simply a means of increasing or decreasing the exposure, usually in increments of $1/3$ stop. When shooting fog, if the pictures are too dark, try increasing the exposure by $1/3$ stop. If you still think

the images are too dark, increase the exposure by $2/3$ stop. You can check the results on the LCD, and in this way, you can tweak the exposure until it's perfect.

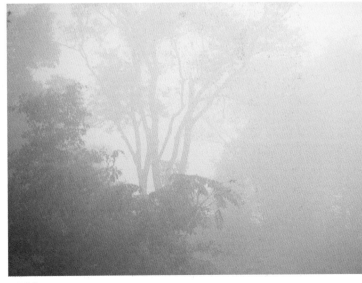

14.13

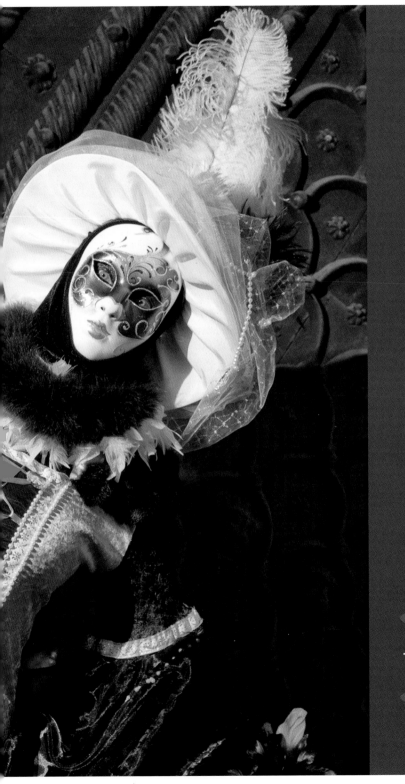

Flash intimidates most photographers, even pros, because it's impossible to assess the accuracy of the exposure as well as how the shadows and highlights affect the subject during the instant the flash fires. However, now we have the advantage of immediate feedback on the LCD monitor, and that takes a lot of the insecurity out of the equation. Don't assume that experienced professional photographers know exactly how the light from a flash will look. We don't. In the past, we used Polaroid test prints to see how our lighting setup was illuminating our subjects. Now, just like everyone else, we use the LCD on the back of the camera to determine if our lighting is correct or if it needs tweaking.

TAKE THE FLASH OFF THE CAMERA

15.1

right

On-camera flash has its place. It is convenient, easy to use, and it functions automatically. However, it doesn't offer the artistry or the drama that is associated with off-camera flash.

Why Bother?

Portable on-camera flash is the least attractive type of artificial lighting photographers use. It is harsh, flat, and it removes the impression that subjects are three-dimensional because it obliterates the shadows that define depth. In addition, the shadows that are created behind your subjects are often unattractive and distracting. The picture of the Moloch gibbon (**15.1**, left) is an example, and you can see how the animal looks two-dimensional and how even its hair seems without depth or texture.

Just like sunrise and sunset are dramatically different (and much more beautiful) than mid-day sunlight, the same is true of off-camera flash compared to on-camera flash. The angle of the light creates depth, dimension, texture, interesting highlights and shadows, and drama. The portrait I did of a costumed Carnival participant against a beautiful door (**15.2**, left) is an example. Notice how rich the texture is on the fabric, and the angle of the light illuminated half the mask, while the opposite side is in shadow. This adds a lot more interest and drama to the subject, and at the same time, the ornate door in the background has more depth. The shadow of the model is going diagonally upward on the right side because the flash was placed fairly low on the left.

How Does it Work?

Let me explain what "off-camera flash" really entails. The flash must be held away from the camera at least at a 45° angle to the lens axis. Imagine straight lines connecting the center of your lens and the center of the flash head to your subject (see **figure A**). Those two lines (the flash-to-subject line and the lens-to-subject line) should form at least a 45° angle. This means that if you are photographing a subject that is more than

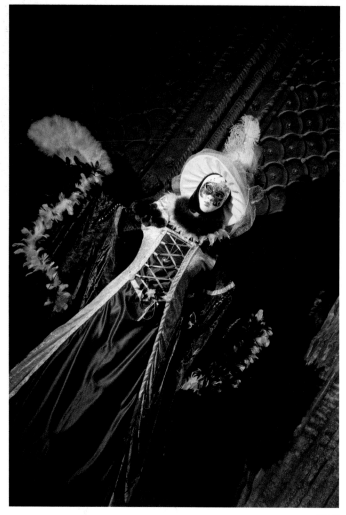

15.2

15.3

about three feet away, you'll need someone else to hold the flash for you or you must put the flash unit on a light stand. On the other hand, if you are shooting a macro subject like the juvenile alligator I shot during one of my semi-annual frog and reptile workshops in St. Louis (**15.3**, above), you can handhold the flash at arm's length because it's easy to achieve that 45° angular separation at close range. This picture was taken with the flash held right in front of the reptile, and that made a 90° angle, which was possible only because I was so close.

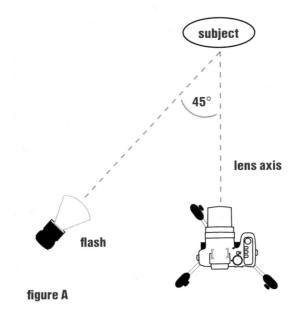

figure A

You don't need elaborate studio lighting to achieve artistic results with flash. I used a single off-camera portable flash to photograph a still life (**15.4**, below), and the rich texture is simply the result of the light being used at about a 60° angle to the lens axis. There is a reflection off the large leaf, and I could have prevented it by angling the leaf so that it didn't bounce the light back into the lens. Softboxes and white umbrellas that studio photographers use would have minimized or eliminated this kind of reflection, too, but nevertheless, I think the lighting is quite beautiful here, given the fact that it was done with only a portable flash.

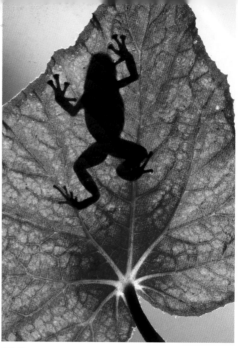

15.5

Methods for Off-Camera Flash

When a flash sits on the hotshoe of the camera, it is automatically triggered as the picture is taken, but when it is removed and used off to the side, there are four ways to fire it.

1 You can use a wireless transmitter, such as the Pocket Wizard (**figure B**, below). This works on a radio frequency, and that means it will fire a flash even without line of sight. This is very convenient because if the flash is placed behind the subject, the Pocket Wizard will still trigger it, as was the case for the photo of the frog silhouetted on the leaf (**15.5**, above). Another option for wirelessly firing flash units is the Canon ST-E2. This is less expensive, but it works on an infrared signal, which requires line of sight. (The Canon unit must be able to "see" the flash in order to trigger it.) The ST-E2 works with both Canon and Nikon flash units as does the Pocket Wizard.

15.4

figure B

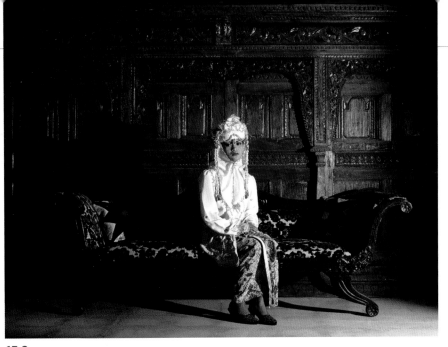

right

I had to use off-camera flash in this portrait of a Javanese bride from Indonesia to avoid the reflection of the light in the high-gloss woodwork behind her.

15.6

2 You can use a connecting cable from the camera to the flash. This is inexpensive, but the length of the cable will limit where the flash can be placed. In addition, these cables are notorious for malfunctioning, so I would recommend carrying a backup.

3 If you have two flash units, one can act as the master and the off-camera unit can act as the slave. With this setup, the two units can be set so that when the master fires (triggered by the camera), it triggers the slave. The master unit has to be somehow connected to the camera, via either a cable or a transmitter, or it can be simply placed on the camera's hotshoe. If you only want the light from the slave, then you can either turn the power down on the master or point it straight up to reduce or eliminate its light.

4 In a dark environment, you can open the shutter for a relatively long exposure (I usually use $1/2$ second) and then an assistant, upon hearing the shutter open, can push the test button on the unit to manually fire the flash. I have done this many, many times and it works just fine. I took the portrait of a Javanese bride in Indonesia (**15.6**, above) this way. I didn't have a wireless transmitter with me, so I asked an assistant to trigger the flash when he heard the shutter open. I counted to three and then I opened the shutter of the camera. Sometimes he wasn't fast enough, but most of the time he was able to fire the flash during the $1/2$-second interval. I used a small lens aperture so the muted ambient light didn't add an additional exposure. Note that the hand-carved wood background was varnished, and had I used direct on-camera flash, there would have been a terrible reflection in the shiny surface of the wood. In retrospect, I should have had the assistant climb a ladder and hold the flash from a height so the shadow of the model would have fallen down to my left. Right now, her shadow is on the carved background and that's my only complaint about this photograph.

When to Use Off-Camera Flash

Off-camera flash is very useful for bringing out texture when photographing subjects with very little relief. For example, the stone carving on a temple in Cambodia (**15.7**, right) was about ½ inch deep. On-camera flash would have made this seem flat and dimensionless. By placing the flash unit against the wall and off to one side, the light skimmed the surface, revealing the beauty of the ancient artwork.

I also like to use off-camera flash in situations where it's completely unexpected. In the night shot of pacas—rarely seen nocturnal jungle rodents (**15.8**, right, below)—my local guide in Costa Rica baited them with food and then he held a single flash at about a 100° angle to the lens axis. This was slightly behind the animals, and that provided the rim lighting that separates them from the darkness. A second off-camera flash was placed on the ground to the left, and that provided illumination from the front to show detail in their faces and bodies.

You can do a lot with portraiture and off-camera flash, both indoors and outdoors. By using the flash exposure compensation feature, which varies the flash output, you can give more or less emphasis to the subject as compared to the background. In addition, you can use the camera exposure compensation to adjust how much the ambient light affects the picture. For example, in the Carnival shot (**15.9**, opposite) I took on St. George Island in Italy, I lowered the exposure on the background by using -⅔ stop on the camera's exposure compensation. This made the background darker than the model. In post-processing, I increased the saturation of the blue tones to provide further contrast between subject and background.

15.7

15.8

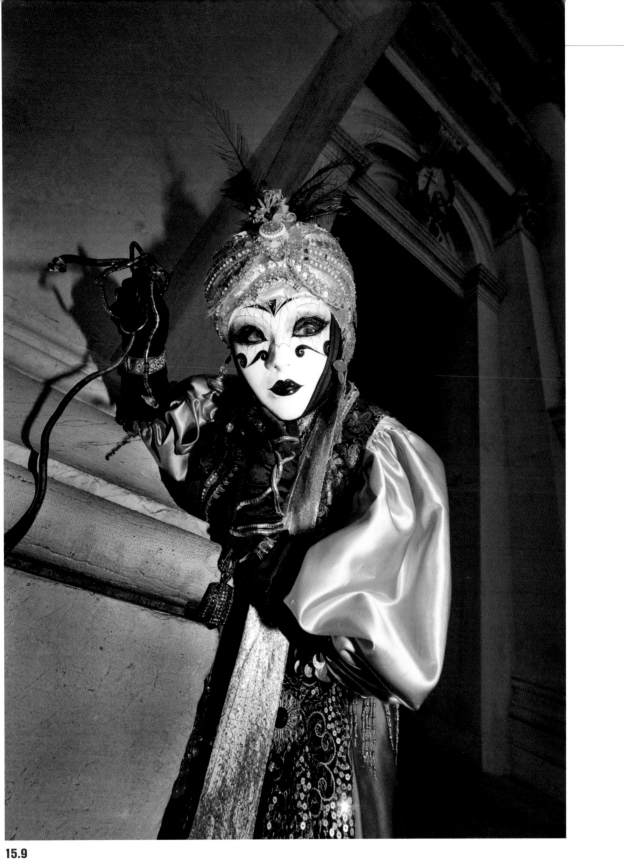

15.9

Chapter Fifteen

INDEX